IMAGES
of Aviation

SOARING AND GLIDING
THE SLEEPING BEAR DUNES
NATIONAL LAKESHORE AREA

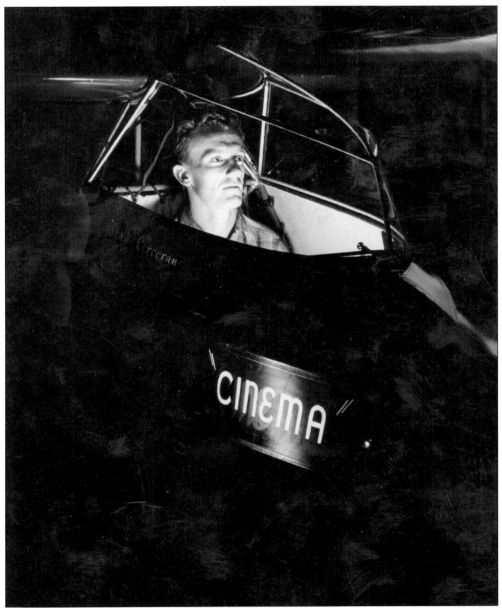

Frankfort's Stan Corcoran, one of America's greatest sailplane pilots and designers, sits in his Cinema glider. This photograph was published in the May 1942 *Popular Mechanics* magazine.

On the cover: Please see page 77. (Courtesy of the author's collection.)

IMAGES
of Aviation

SOARING AND GLIDING
THE SLEEPING BEAR DUNES
NATIONAL LAKESHORE AREA

Jeffery P. Sandman and Peter R. Sandman

"Here's to the "Bucket List!"

Merry Christmas Dad!!

2019

all my love ♡
xo "Deborah"



ARCADIA
PUBLISHING

Published by Arcadia Publishing
Charleston, South Carolina

Printed in the United States of America

Library of Congress Control Number: 2006924872

For all general information, please contact Arcadia Publishing:
Telephone 843-853-2070
Fax 843-853-0044
E-mail sales@arcadiapublishing.com
For customer service and orders:
Toll-Free 1-888-313-2665

Visit us on the Internet at www.arcadiapublishing.com

*To Stollie and Elaine, for preserving the soaring
heritage in northwestern Michigan*

CONTENTS

ACKNOWLEDGMENTS

We would like to thank the following people who over the years made this book possible by either sharing their knowledge of those "glory days" through interviews and/or photographs: William F. Sherman, William Skinner, Paul Bikle, Pauline Price Warner, Stollie and Elaine Larson, Stan Spamer, Bernie Strom, Ted Bellak, Vic Saudek, William J. Perfield, Kenny Carr, Chuck Kohls, many members of the Vultures Soaring Club, Dick Schreder, R. E. and Chuck Franklin, Bill Bennett, Francis Rogallo, Taras Kiceniuk Jr., Dave Kilbourne, Helen Montgomery Hine, Elmer Zook, Jim Smiley, Eb Geyer, Emma Didrickson Dixon, Roy Gay, Jack Laister, Dayton Hardy, Bob Denton, Pete and Nadine Panos, Emerson Mehlhose, Helen Barringer Shober, Eugene "Hunchy" Hansknecht, John House, Fred Herman, Trudy Herman Delker, Cyril "Dusty" Bennett, Bill Gallagher and Peter Smith of the National Soaring Museum, Dave Taghon of the Empire Area Historical Museum, and many, many others we are sure we left out.

Special gratitude goes to Stan Corcoran, Eliot Noyes, Joy Schultz, and John Nowak for their confidence that we would preserve and share their photographs, diaries, and other soaring memorabilia through the years.

—Jeffery and Peter Sandman

Warmest regards to families and friends of John Peterson and Gus Carlson of the *Benzie County Patriot*; Father Marquette historian Catherine Stebbins; and Frankfort High School teacher Bertine Orr who got me hooked on the "Big Three:" journalism, history, and the story of soaring in the Sleeping Bear Dunes area.

—Peter Sandman

INTRODUCTION

"For once you have tasted flight, you will walk the earth with your eyes turned skyward; for there you have been, and there you long to return," Leonardo Da Vinci said. Since Da Vinci's first scientific observations on the subject of flight, man has been enthralled with motorless flight. Beginning with Octave Chanute in the 1890s, many of those people have experimented with soaring and gliding along the bluffs of Lake Michigan from Michigan City, Indiana, where Chanute conducted many of his flights, to the Sleeping Bear Dunes National Lakeshore area nearly 300 miles north.

The first successful flight of a glider built in Michigan was just miles from Sleeping Bear when Edwin Elton Smith of Traverse City soared 600 feet at an altitude of 50 feet on October 17, 1909. Charles Augustine built the craft at a farm near Arbutus Lake. Twenty years later, Hawley Bowlus flew over the clay bluffs south of Ludington. Bowlus had given Col. Charles Lindbergh his first glider lessons earlier in 1929. In 1930, a young pilot flew a glider for 27 miles along the shore in the vicinity of South Haven.

Determined to find out all the possibilities of soaring along the Lake Michigan bluffs, a group of businessmen from Detroit, who had formed a glider club, began expeditions to the Sleeping Bear Dunes near Empire. What they found in the area was some of the best soaring terrain in the country. The dunes provided a high, steep slope against and up over which the wind will blow, keeping gliders soaring for hours in this upward deflected current of air, and its ridge had amble backing, sufficient length, and amble space on top of the ridge and at the bottom for taking off and landing. Most important, the dunes area provided several ridges, facing in the several directions from which the wind is liable to blow, so that flying may be conducted every day.

By 1935, the group began making the treks every few weeks promoting the sport and the area through the West Michigan Tourist and Resort Association, the Traverse City Chamber of Commerce, and the nation's foremost soaring officials themselves. Dr. Wolfgang Klemperer, who had been the first to soar at the Wasserkuppe in Germany in 1920; Capt. Ralph S. Barnaby, who had broken Orville Wright's soaring record at Cape Cod in 1929; early Soaring Society of America official Lewin Barringer; and financier Richard C. duPont began to tout the Sleeping Bear Dunes area as one of the best and safest sites to soar.

The work by the tourist association and the chamber of commerce was the first concerted effort to promote tourism in northern Michigan with a recreation-related event. With talk of developing the Sleeping Bear Dunes area into a state park and the appropriation of monies from the legislature to promote the state along with new visitor centers opening up in the

southwestern part of the state and at the tip of the Michigan-Wisconsin border in the Upper Peninsula, tourism to the northwestern Michigan area was being born.

The following year, the Detroit-based glider pilots hosted a very successful and competitive meet that attracted young college students including Jack Laister and Paul Bikle, the likes of who would help us win World War II with their aeronautic development and designs and eventually land us on the moon with their research.

By late 1937, the small towns of Frankfort and Elberta, just south of the dunes area, caught the "soaring fever" and began promoting the sport to national attention, convincing two of the best glider pilots in the nation, Stan Corcoran and Ted Bellak, to stay and start a glider factory and a soaring school. Soaring became an everyday word, and publications such as *National Geographic*, *Reader's Digest*, *Saturday Evening Post*, and *Life* all covered stories of the area's romance with the sport.

With the onset of the war, the Frankfort Sailplane Company received government contracts to build training gliders, and although the company moved to Joliet, Illinois, for financial reasons, the name stayed the same, and many of the local employees moved with the company. Many who had received their glider licenses from Corcoran and Bellak at the Frankfort Soaring School ended up training others in the army air corps at LaMesa Field and Stamford Flying School in Texas.

When the war ended, the soaring activity in the area was resumed, mainly through the efforts of Zada Price. He organized soaring meets that were competitive, fun, and mixed with a hospitality that had been displayed in the 1930s. The area became known for great soaring possibilities in an informal atmosphere. Price would die in a glider crash in 1960, but his daughter and son-in-law Elaine and Stollie Larson continued the promotion of the sport in the area.

In the early 1970s, they, along with others associated with the sport, decided to honor those pilots and designers who had promoted the sport throughout the years and had gone on to national fame by holding an annual festival climaxed with a hall-of-fame banquet. The soaring legends came back, some after not being in the area for decades, and those honored comprised a virtual who's who of American aeronautics.

Soaring is still very prevalent as the Northwest Soaring Club, an offshoot of the original organization that Price began after World War II, is logging numerous glider flights daily from the Frankfort airport. By 1973, hang glider pilots discovered the bluffs south of Elberta to fly their kite-like crafts and conduct meets. In the past decade, paragliders have joined in as well.

We hope that this pictorial history of motorless flight in the Sleeping Bear Dunes National Lakeshore thoroughly explains why this area basks in the "silent wings of glory."

One

Soaring Comes
to the Midwest
1929–1935

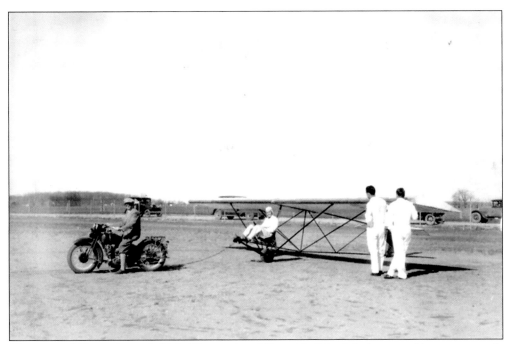

The original Titan Aircraft Club (University of Detroit) glider is being towed by a motorcycle after it was modified from a wooden landing skid to a wheel in 1930. William J. Perfield and Kenny Carr were instrumental in the modification.

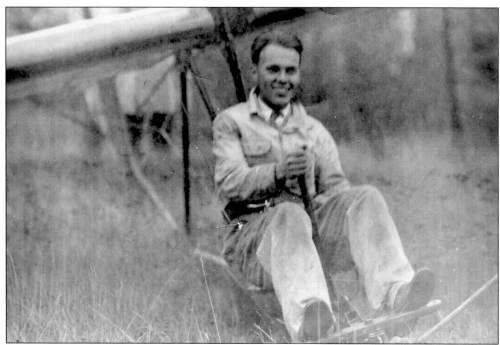

William J. Perfield is in his open fuselage primary glider, built by himself and fellow University of Detroit Glider Club members.

Emerson Mehlhose of Wyandotte, Michigan, is listed in a special survey edition of *Soaring Magazine* as "one of 15 of the early supporters who will remain famous in American soaring." Mehlhose was a regular competitor at the meets at Frankfort. As a Massachusetts Institute of Technology (MIT) student, he and his fellow Aeronautic Engineering Society classmates took an early National Soaring Contest in Elmira, New York, by storm, capturing the Sherman Fairchild Cup for greatest total time in the air. Mehlhose, himself, was up for a six-hour-42-minute flight in a sailplane he called *The Professor*.

In 1928, Roswell E. Franklin (above), a mechanical engineering professor at the University of Michigan, and his brother Wallace discovered a student glider club building a German Zoegling (primary) training glider. The Franklin brothers realized that an improved Zoegling had the potential to become a popular glider in the United States, and they quickly set about constructing their own version. At this time, no domestic glider manufacturers existed. American interests in motorless flights lagged far behind Germany, the nation that began the sport gliding movement during the early 1920s. The Franklin glider 9491 incorporated several new modifications; the most significant change involved the landing gear. A single wheel and tire was mounted in the fuselage behind the pilot, in place of the wooden skid used on the original Zoegling. The Franklin brothers retained a smaller skid mounted on shock absorbers ahead of the wheel. The device prevented damage to the nose during landing and also functioned as a brake, and it became a standard feature on most American sport gliders during the next two decades. The Franklin brothers built and sold well over 100 PS-2 aircraft, and for a time, it was the most popular training glider in the country.

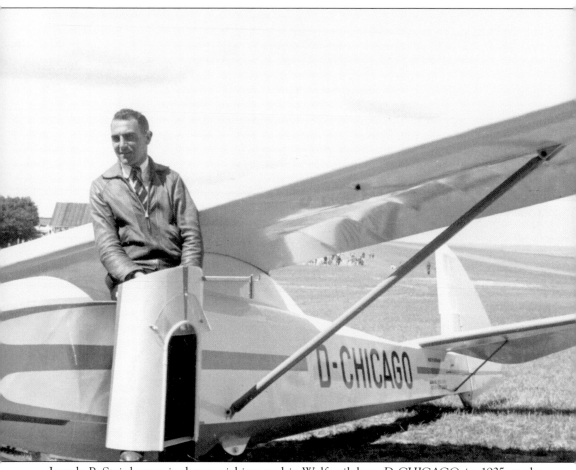

Joseph P. Steinhauser is shown picking up his Wolf sailplane *D CHICAGO* in 1935 at the Hornberg in Germany. Steinhauser, a native German who lived in Chicago, was one of the early pilots at Sleeping Bear Dunes. (Courtesy of the National Soaring Museum.)

Cadillac 7780

A. B. C. GLIDER CLUB
No. 25
of DETROIT
Associated with National Glider Association

Rep. by

_____ **902 Lafayette Bldg.**

Shown here is a business card of the A. B. C. (American Business Club) Glider Club of Detroit, which was associated with the National Glider Association, predecessor to today's Soaring Society of America.

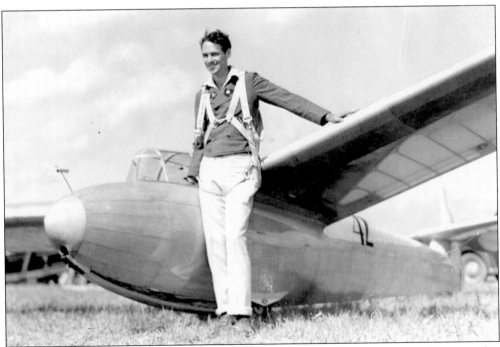

Lewin Barringer, the general manager of the Soaring Society of America, stands next to his Minimoa sailplane. (Courtesy of the National Soaring Museum.)

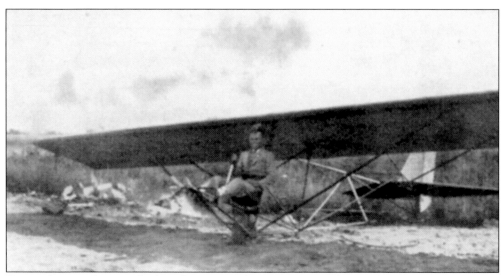

Kenny Carr is photographed at the National Air Races in Cleveland in 1930 in the Titan Aircraft Club (University of Detroit) glider. An engineering graduate of the university, he was employed by Plymouth Motors until he joined Voltee Aircraft Company. Before his retirement, he had devoted many years to efforts of the Engineers Council for Professional Development. Also that year, he flew a pontoon-equipped sailplane, towed by a motorboat, from takeoff in the Detroit River, under the Ambassador Bridge, to Toledo, Ohio. The goal of the flight, sponsored by Radio Station WXYZ, was Cleveland, but rough water in Lake Erie impeded the motorboat.

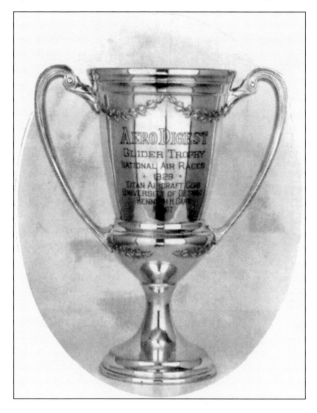

This early glider trophy was won by Kenny Carr at the National Air Races in Cleveland in 1930.

Aeroplane Rides
$1.00

Saturday and Sunday
August 1-2

at the

FRANKFORT AIRPORT

Fast government licensed Whirlwind powered open Travelair. Large supercharged Wasp powered 7-passenger Stinson Cabin Airliner. Flown by transport pilots.

STUNTING EXHIBITION AT 2:30 ON SATURDAY and SUNDAY

PARACHUTE JUMP BY DARE DEVIL BILL ROSS, SUNDAY

In 1935, a few years before gliders made their way to the Frankfort Airport, area people were able to get airplane rides and watch stunt exhibitions and parachute jumps.

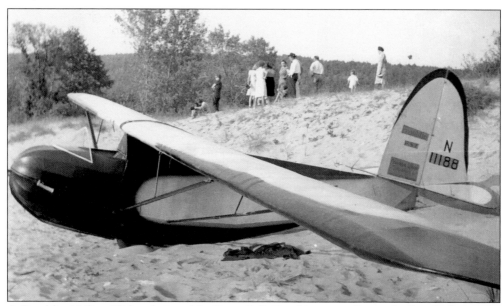

A Franklin Utility Glider, designed by Roswell E. Franklin, sits idly on the beach during the 1938 American Open meet. Detroit's John Nowak broke the state glider endurance record on September 29, 1935, using a Franklin Utility, staying aloft three hours and 15 minutes. The secondary, or utility glider, as the American version was generally called, is more refined than the primary in that it has an enclosed fuselage, a more efficient wing braced by streamlined struts, and a pneumatic landing wheel equipped with a brake.

Roswell E. Franklin, a professor at the University of Michigan, designed the most popular utility glider in the 1930s, the Franklin PS-2. Its wing span was 36 feet, and its empty weight was 220 pounds. Franklin, along with Arthur Schultz, pioneered the Sleeping Bear Dunes area for soaring. By 1973, when he returned to Frankfort to be the only unanimous choice of the Frankfort-Elberta National Soaring Hall of Fame's first class of 11 inductees, he related that there were only three PS-2s still active.

William J. Perfield was born in Tacoma, Washington, on June 9, 1907, and graduated from the University of Detroit with an aero-engineering degree in 1930. With Kenny Carr, he formed the University of Detroit Glider Club on December 28, 1928, and designed an open fuselage primary training glider. Club members built the glider, and its first flight was Decoration (now Memorial) Day in 1929. The following year, at the age of 22, he addressed the Detroit Aeronautical meeting of the Society of Automotive Engineers stating that "the practical value of gliding to modern aviation is much debated, but that gliding is certainly in some respects an asset to the aeronautic industry." Perfield warned at the meeting that the automotive industry was in a position to do a great service to the expanding glider movement by "making his technical knowledge and experience available to the amateur glider enthusiast in the interests of safety."

One of the staunch promoters of soaring at Sleeping Bear Dunes was Detroit businessman William F. Sherman, an active member of the University of Detroit Glider Club. He assisted in building the first metal-frame, primary glider with a single large donut tire for landings. On the first expeditions to Sleeping Bear, he was the official observer for the National Aeronautics Association. An editor for a technical magazine, he also was an engineer for Chevrolet and later a director of the engineering division of the Motor Vehicles Manufacturers Association. In the 1970s, he was still flying a Cessna 182 Skylane to attend many of the soaring meets and functions.

William Perfield contributed to many of the early books on gliding with his engineering expertise and assisted Arthur Schultz and John Nowak with the A. B. C. Glider Club of Detroit. Perfield qualified for the FAI Glider Certificate on August 10, 1931, a certificate necessary in order to compete in national or international contests. His certificate, obtained at the National Soaring Meet in Elmira, New York, was signed by Orville Wright, chairman of the contest committee.

Arthur Bernhardt Schultz was the moving force behind the soaring movement in the Midwest, and specifically, northern Michigan. Schultz, born on February 1, 1904, in Schenectady, New York, was associated with the American Business Club (A. B. C.), a glider group based out of Detroit, when they started looking for soaring possibilities. In a letter to the Traverse City Chamber of Commerce on May 23, 1935, the meticulous Schultz, who kept diaries and copies of all correspondence related to the sport, stated that his group was "determined to find out definitely all the possibilities of soaring in Michigan," and "the writer and others have at various times scouted practically the whole State. The possibilities inland are nil and the shores of Lake Michigan the only possibility. In 1932 we carefully checked the dunes around Michigan City and St. Joseph. In 1933 we made a few attempts at soaring at Ludington and investigated the possibilities as far north as Frankfort and south to Muskegon. Last year we thoroughly investigated the shore from Charlevoix to Cross Village, and tried a few flights from a high ridge back of Petoskey. This territory looked quite promising, but not good enough to thoroughly interest us. This year we investigated all of Leelanau Peninsula and as far south as Point Betsie and have found some remarkable soaring possibilities."

John Nowak — PILOT LOG BOOK — *Non. Comm 453*

DATE BROUGHT FORWARD	NO. OF FLIGHTS	TIME IN AIR	DISTANCE FLOWN PLACE	REG. MARK OR TYPE OF PLANE USED	NATURE OF FLIGHTS	CERTIFIED BY
10-25	2	4 MIN	PONTIAC	C H 43?	1000 ft. Line	a w S
11-25	5	15 "	"	"	10 MILE WIND	a w S
12-7	1	19 "	"	"	Airplane Tow — Broke	a w S
4-7-35	1	18 "	"	"	" "	a w S
5-19	10	35 "	"	"	Auto Tows	J. N.
5-30	2	10 "	S. Bear	1.	first hop off the Bear	J. N.
5-31	3	9 h	" "	"	Practice hops — Beach	J. N.
6-1	3	10 "	" "	"	" "	J. N.
6-9	3	8	Pontiac	"	1000 ft. Alt.	J. N.
6-16	2	7 "	"	"		J. N.
CARRIED FORWARD	32					

John Nowak's pilot log book reveals his flight on May 30, 1935, at Sleeping Bear Dunes. Under "Nature of Flights" he wrote "first hop off the Bear." Nowak had two flights that day for a total of 10 minutes.

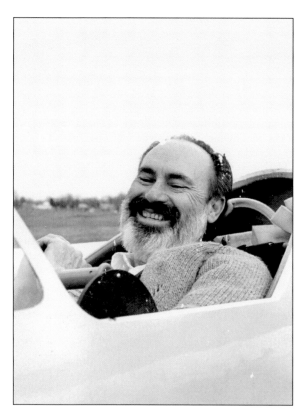

Charles H. "Chuck" Franklin's acquaintance with and enthusiasm for soaring began at a very early age indeed. At the first U.S. National Soaring Contest in 1930 in Elmira, New York, one-and-a-half-year-old Chuck Franklin was on hand with his father, R. E. Franklin, to witness the launchings. Soon after, he began his own first-hand experience with glider flying—sitting on his father's lap in the single-place Franklin PS-2 at Sleeping Bear Dunes. He made his first solo flights at the age of 10. Because there were no two-place trainers at the time, the young solo pilot received shouted instructions from his father, who ran alongside the auto-launched glider as it floated a few feet above the ground. Chuck Franklin, later a project engineer with Chemotronics International Incorporated, is shown in a PIK-20B sailplane.

Two

THE EXPEDITIONS TO THE SLEEPING BEAR DUNES
1936–1937

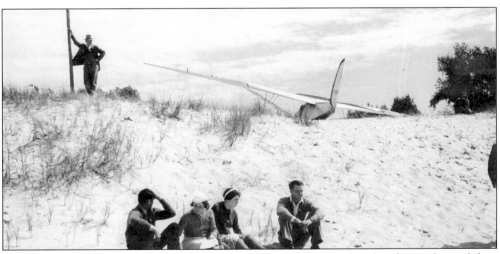

Dr. Wolfgang Klemperer, the father of soaring, leans on the wind sock pole watching gliding activity at Sleeping Bear Dunes during the 1937 Midwest Open Soaring meet north of Empire. Klemperer, who began soaring at the Wasserkuppe in Germany, designed the first sporting glider, a German Schwarzer Teufel. He had broken the Wright brothers' soaring duration record in 1921, staying aloft for 21 minutes using ridge lift. Klemperer, who had come to America in 1924 to aid in the establishment of the Goodyear-Zeppelin facility in Akron, Ohio, developed a points system to award the American Business Club (A. B. C.) trophy at the Midwest meet that year. *The Benzie County Patriot,* Frankfort's weekly newspaper run by A. P. "Big Pete" Peterson, who would become a big promoter of the sport, ran a headline acknowledging Klemperer's presence, "Grandfather of Soaring Came to Michigan Meet."

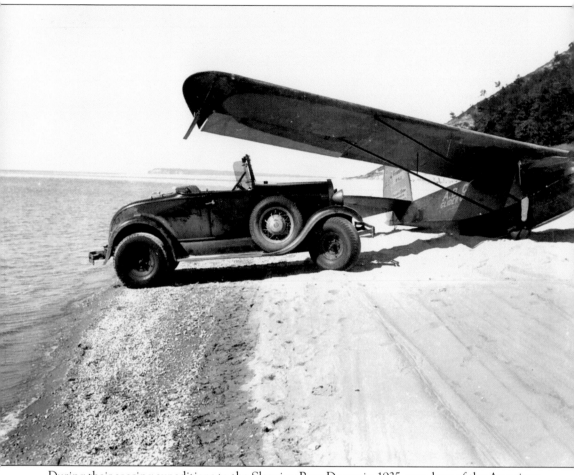

During their soaring expeditions to the Sleeping Bear Dunes in 1935, members of the American Business Club (A. B. C.) Glider Club noted that "auto towing for miles up and down the beach can be done at any time" and that the towing was done with a standard Model A Ford roadster equipped with nine-by-13 doughnut tires. "These large tires solved completely the difficulty of towing on the beach," Arthur Schultz said. When preparations for the 1936 soaring season were beginning, Amos L. Wood of the Purdue Glider Club even inquired as to where he could get balloon tires. "I will be driving my car, a Model A 1930 roadster and should you fellows in the A.B.C. club not be able to get up (to Empire) what chances could there be of getting a set from you for the week?" Wood asked Schultz.

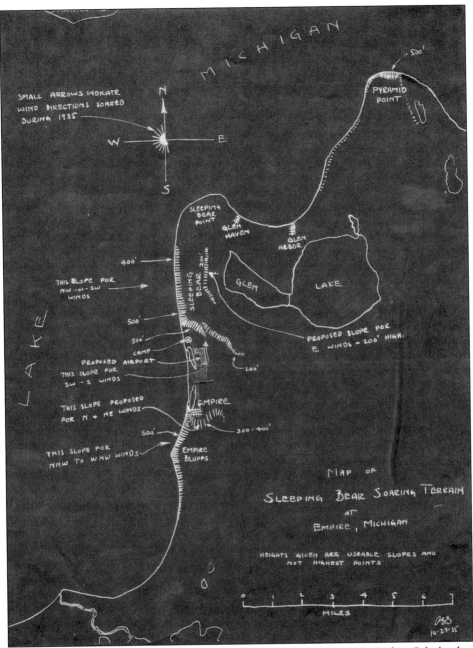

After four soaring expeditions to the Sleeping Bear Dunes area in 1935, Arthur Schultz drew a map of proposed areas for soaring activities, and he also set out a "Program for the Development of the Sleeping Bear Soaring Terrain," which included "assurance must be established that the privilege of towing gliders off the beach will be a definite one;" that "an airport should be established suitable for both glider training and for airplane landings;" that "a camping area, under the supervision of the State Parks Division of the Michigan State Highway Department, should be provided large enough to accommodate a large number of campers;" and that "the roads and trails in this vicinity should be improved so that transport of equipment will be easier and less hazardous and the traffic jams of the spectators be less aggravating."

George Johnson, who was the cashier of the Empire State Bank and then its president, was leery at first of the possibilities of soaring helping the economy of the area, but then became one of its prime promoters. Johnson got permission from the owners of the Slyfield property to hold the first soaring meet of 1936 there and then foreclosed on another piece of property that would be used exclusively for the glider pilots. (Courtesy of the Empire Area Historical Museum.)

Orson R. McClary, an orchard manager in Empire, was instrumental through the winter of 1935–1936 in securing a site exclusively for soaring in the dunes area. McClary, Jim Cook of the West Michigan Tourist and Resort Association, and Art Schultz of the Detroit Glider Council were in constant contact. McClary would also advise the soaring expedition group of weather ground conditions by telegram on many occasions. (Courtesy of the Empire Area Historical Museum.)

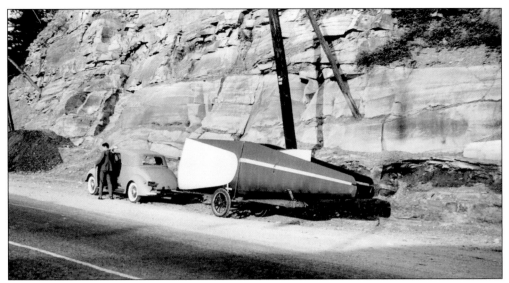

Soaring Society of America general manager Lewin Barringer takes a break alongside a highway in Pennsylvania on his trek with his Stevens-Franklin glider and trailer to Sleeping Bear Dunes for the 1937 soaring meet north of Empire. "Ever since you wrote me of this site when I was still in Persia I have been wanting to go out there and try it out," Barringer wrote Art Schultz three weeks before the meet.

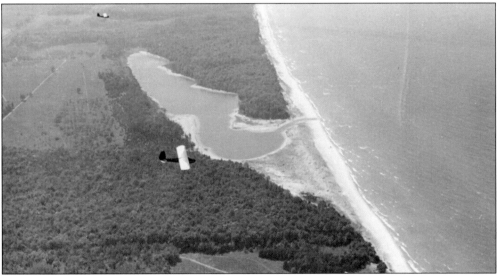

Gliders soar above North Bar Lake, north of the village of Empire, during the 1937 Midwest Open Soaring Meet. Five years later, residents of Benzie and Leelanau counties, interested in protecting their own recreational opportunities from the increasing privatization of lake shore lands as well as attracting a larger share of the automobile camper trade, convinced the Department of Conservation to survey the area for potential parklands along the entire Lake Michigan shoreline between Frankfort and Leland. John Rogers, the assistant chief of the Division of Parks and Recreation, headed the survey, and his evaluation was strongly influenced by his interpretation of the mission of state parks as "scenes of active recreation." Thus, Rogers discounted Benzie County sites and felt that the Glen Lake and Sleeping Bear Dunes area offered the "greatest attraction."

2nd Annual Mid-west
GLIDER
MEET

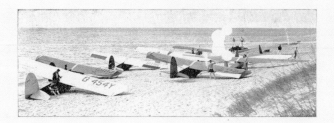

JUST NORTH OF

EMPIRE
ON SLEEPING BEAR DUNE
September 4 to 12 INCLUSIVE

Hugh J. Gray and Jim Cook of the West Michigan Tourist and Resort Association and Don Weeks, the secretary of the Traverse City Chamber of Commerce, had posters out early in 1937 to publicize the glider meet at Empire. The chamber, in cooperation with the American Business Club (Art Schultz's Detroit glider group, A. B. C.), were beginning to send representatives to tourist expositions and advertising material of the area, which included the Cherry Festival and sporting activities in the area, specifically soaring and shuffleboard, to the major distribution spots in the Midwest. These spots included two recently opened tourist information locations: one at U.S. 13 near New Buffalo in southwestern Michigan, where travelers from Chicago and St. Louis were abundant, and one at Menominee on the Wisconsin border, where travelers could board a car ferry and head to Michigan. Two other events were happening in early 1937 as the area prepared for its "greatest tourist and resort season in history." There was legislative action from the state to actually set aside $300,000 to advertise Michigan as a destination, and there was growing talk about turning the Sleeping Bear area into a state park.

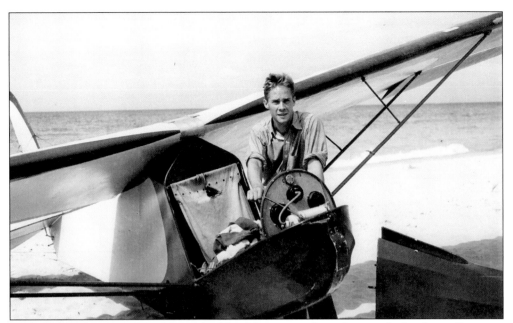

At the helm of a Stevens-Franklin glider, Eliot Noyes poses for a photograph that Lewin Barringer took in 1937 at Sleeping Bear Dunes. Later, as an industrial designer, Noyes became known for his work for IBM, specifically the IBM Selectric typewriter and for the Mobil Oil Corporation for his work with the service station prototype and cylindrical patrol pumps. Nearly 30 years after his death in 1977, his name is still associated with the Harvard University Graduate School of Design.

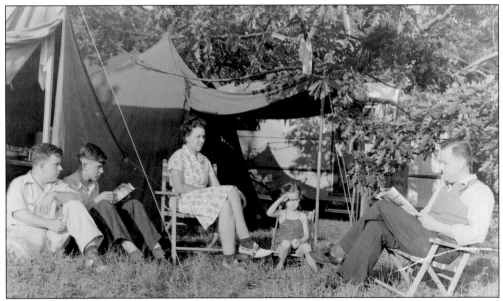

In a letter about the Midwest Soaring Meet at Empire, William Sherman wrote, "Excellent camping grounds will be found at Contest Headquarters, a small field adjacent to Lake Michigan, three miles north of Empire. It is assumed that the majority of pilots and crews will prefer to camp out. Don't hesitate to bring several extra blankets as this location is 200 to 300 miles father north than most of us are accustomed to." Pictured in this family camping scene are Col. Larry Ely (right), his wife Kate, daughter Barbara, their nephew and William Skinner (far left).

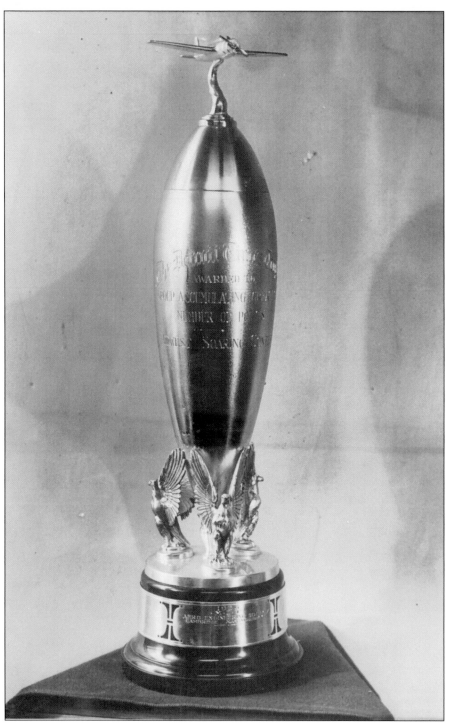

The Detroit Times (one of three major daily newspapers in the Motor City at the time) trophy was awarded at the Midwest Open Soaring Meets to the group highest in the point standings. In 1936, the MIT Aeronautical Engineering Society Glider Division captured the trophy. John J. Wallace and Ben W. Badenoch comprised the MIT group.

In 1936, Dr. Wolfgang Klemperer of the Akron group did not bring the Cadet Utility glider (shown in the foreground) to the soaring meet at Empire, so "the father of soaring" had a one-hour-and-13-minute flight in the American Business Club (A. B. C.) Franklin Utility glider. The following fall, the Cadet Utility glider was in the air for many flights, including Dick Randolph's 10-hour-and-42-minute flight. In 1938, at the first American Open Soaring Meet at Frankfort, Randolph stayed aloft for over 12 hours.

One of Jack Laister's first flights at Sleeping Bear Dunes in 1936 resulted in his Universal two-place glider landing in Lake Michigan.

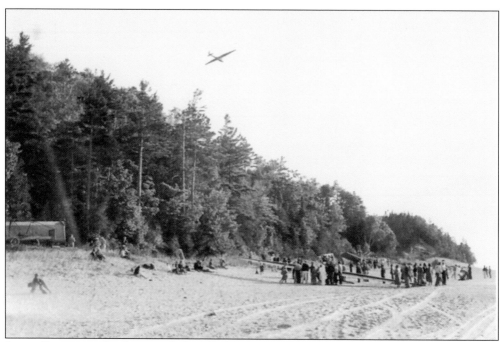

Lewin Barringer takes his first flight off of Point Betsie during the fall of 1937. Barringer, the general manager of the Soaring Society of America, wrote *Flight Without Power* in 1940. Barringer notes, "Certainly one of the most important considerations is the choice of a site for a record attempt. Some of the best places in America are the sand dunes in the vicinity of Frankfort, Michigan, which offer unlimited facilities for landing on the beaches."

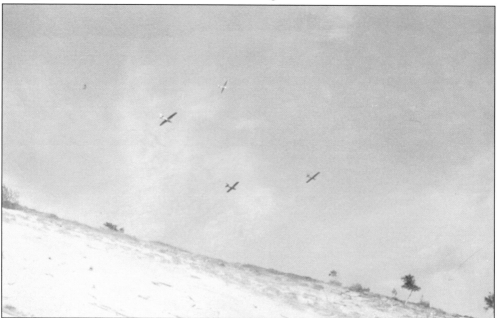

Eliot Noyes took this photograph of five sailplanes in the air at the same time in 1937 with his Leica camera. Over 162 hours were logged in the air at the Sleeping Bear Dunes during the second annual Midwest Open Soaring Meet that year.

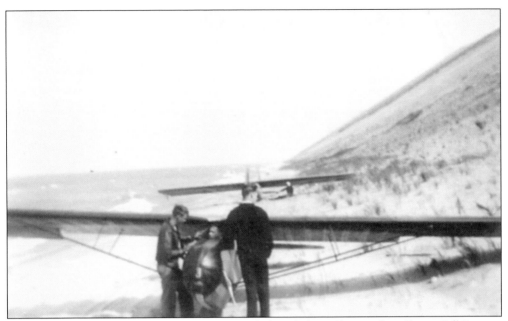

Bill Sherman, in a Franklin Utility glider, gets ready for a flight at Sleeping Bear Dunes. Bill Putnam (left) of Lawrence Institute of Technology and Steve Chris (right) of the University of Detroit Glider Club are standing in front of the glider. Paul Bikle, who became one of the greatest soaring pilots of all time, took this photograph on September 8, 1936, as a member of the University of Detroit club.

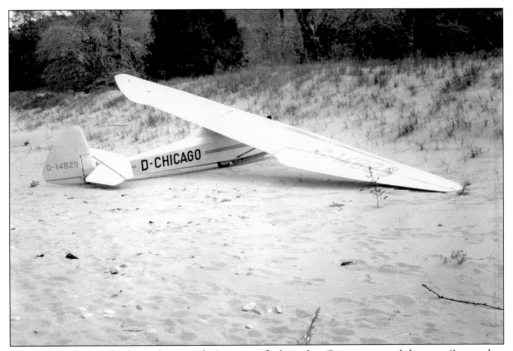

Joseph Steinhauser had a six-hour-and-12-minute flight in his Goppingen sailplane on September 6, 1936, at Sleeping Bear Dunes. The Goppingen was a sailplane built in Steinhauser's native Germany by Martin Schempp and Wolf Hirth.

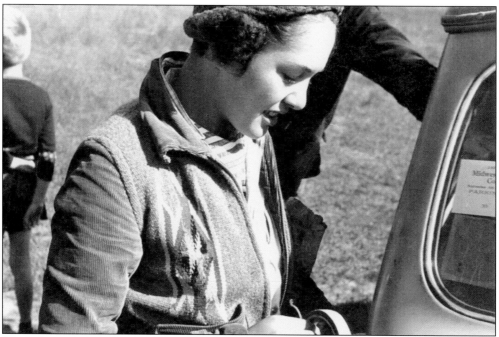

Lewin Barringer's wife, Helen, made the trip from Philadelphia with her husband and Harvard student Eliot Noyes to the 1937 Midwest Open Soaring Meet. "I remember our trip to Michigan in 1937. Eliot Noyes was with us. He was Lewin's spectacular pupil who caught on to gliding immediately at Wings Field in Pennsylvania in a Franklin glider we called 'The Mint Julep'. Eliot enjoyed his first ridge soaring above the beach of Lake Michigan," Helen Barringer Shober wrote in 1974.

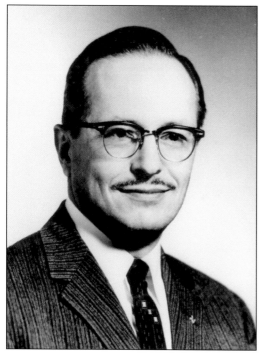

Despite weather conditions for soaring being bad for seven of nine days for the 1937 Midwest Open Soaring Meet at Empire, Elmer Zook was able to fly a "Hawk" owned by the Toledo Gliding Club, setting a new Midwest endurance record by staying aloft 10 hours and 55 minutes. Zook, then of Highland Park, Michigan, and a member of the Lawrence Institute of Technology glider group, had also participated in the 1936 meet at Empire.

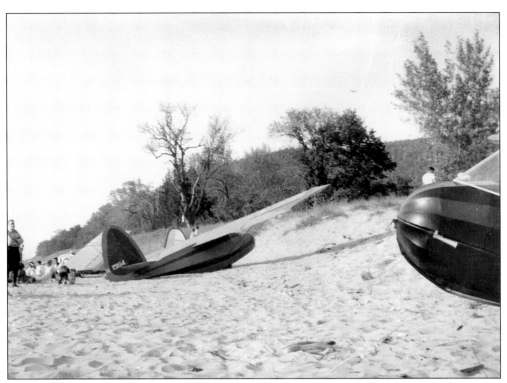

William Sherman flew his Franklin Utility glider (center) on two flights during the 1936 meet at Empire, one of which he was in the air for over two and a half hours. Sherman, a Detroit businessman, was one of the early promoters of soaring in the Sleeping Bear Dunes area.

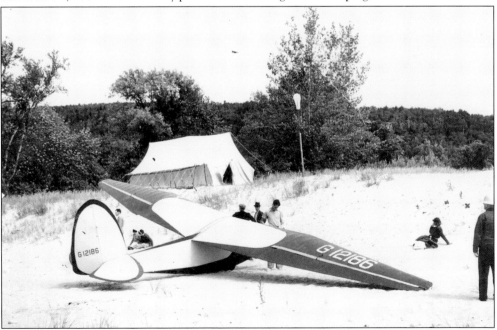

Lewin Barringer stands in front of his Stevens-Franklin sailplane getting it ready for competition during the second annual Midwest Open Soaring Meet in 1937.

Trailers with their gliders inside are parked off the Lake Michigan beach, including, from Birmingham, Michigan, Randall Meeker's Detroit Gull Primary glider at the right. Meeker was one of the foremost winch operators in the 1930s.

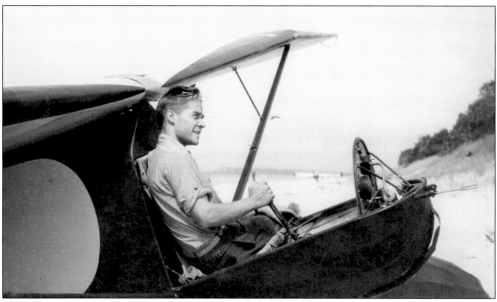

Eliot Fette Noyes is shown at the second Midwest Open Soaring Contest at Sleeping Bear Dunes in 1937. A student at Harvard University, he had for the previous two years studied archaeology with Lewin Barringer at Persepolis in Iran. "He [Lewin] talked gliding constantly and got me very interested in it. When I came home from the expedition, he took me to Wings Field [Philadelphia] and with auto-tow and a tied stick, gradually taught me how to fly the Stevens-Franklin glider," Noyes wrote in 1974, three years before his death.

34

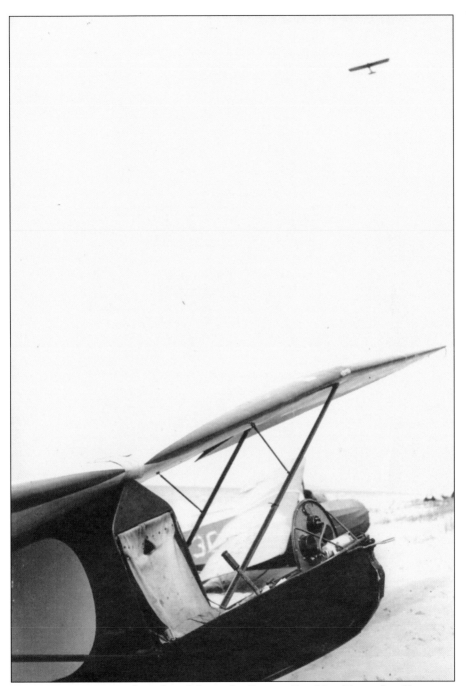

An interesting conversion of a utility glider is the Stevens-Franklin. Tapered, gull wings a span of 48 feet with the same wing area as a standard Franklin Utility were developed by a group of engineering students at the Stevens Institute of Technology to fit on the Franklin fuselage and use the same struts. The increase in control and performance is very marked, the gliding ratio being about 17 to 1 and the sinking speed under three feet per second. One of the early students of the Stevens Institute was Augustus Herring, who helped Octave Chanute with his flight experiments in 1896.

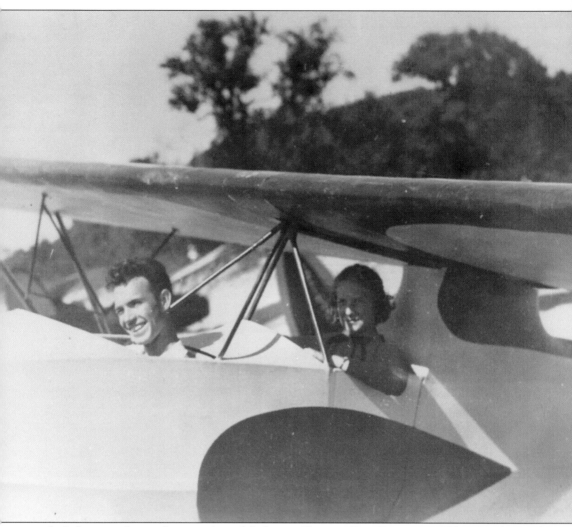

Jack Laister, who made a number of flights at Sleeping Bear Dunes in 1935–1936, designed the CG-10 (nicknamed the "Trojan Horse") during World War II as the Allies made plans to invade Japan. The CG-10 was the first rear-loading aircraft, a glider slightly larger than the B-17. Already an avid model-plane builder, as a ninth grader at Roosevelt High School in Wyandotte, Michigan, he built a full-size primary glider. Laister is shown in his UG2P-1 two-place glider that he first flew in 1935. He won the 1936 intercollegiate competition with this ship at the Wayne County (now Detroit Metro) Airport. Here at Sleeping Bear Dunes, he is seated in the cockpit with the National Cherry Festival Queen. (Courtesy of the National Soaring Museum.)

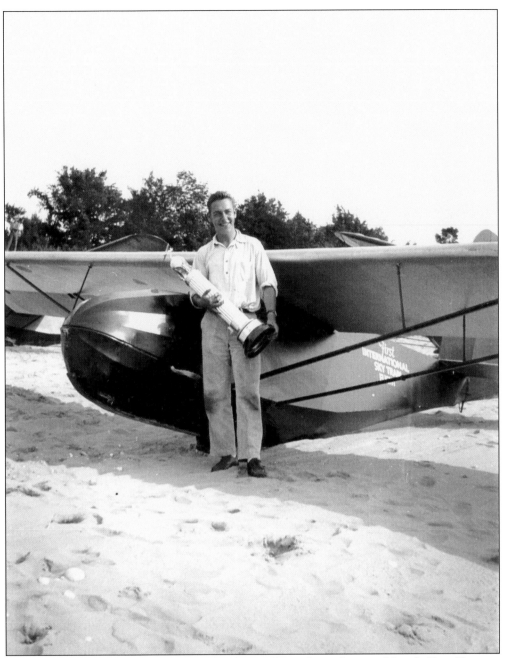

Cornell University's Udo Fischer won the first Midwest Open Soaring Meet held at Sleeping Bear Dunes north of Empire, Michigan, September 5–13, 1936. Fischer had 69 points, awarded for duration and altitude, edging Arthur Schultz (66½) and Joseph Steinhauser (65) among the 16 pilots from seven different states. Fischer holds the American Business Club (A. B. C.) trophy. He also won $8.97 in prize money. In a comprehensive post-contest summary, the Detroit Glider Council stated it "shared credit for introducing his sport and science as an organized venture in Michigan with the citizens of Empire, the West Michigan Tourist and Resort Association, and members of the Traverse City Chamber of Commerce."

Lucean "Whitey" Vanderlip, a 13-year-old boy who lived near the Empire gliding grounds, was taken as a passenger on one of the flights to repay him for watching weather conditions at Sleeping Bear Dunes for the glider pilots. He was the first Empire resident to get a ride in Jack Laister's two-seater. Laister, a member of the Lawrence Institute of Technology soaring group, had been on Arthur Schultz' expeditions to Sleeping Bear in both 1935 and 1936. Now 92, Laister lives in Apple Valley, California.

Whitey Vanderlip was both a "shadow" and an invaluable guide to the pilots during the expeditions to Empire and the dunes in 1936. According to William F. Sherman's figures, the expeditions between May 30, 1935, and May 3, 1936, resulted in soaring flights of an average of 44 minutes. Sherman was the official glider observer for the National Aeronautics Association.

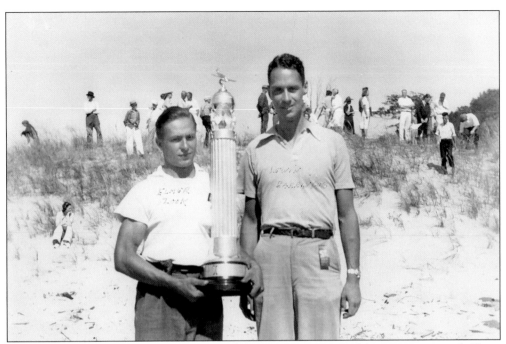

Lewin Barringer (right), general manager of the Soaring Society of America, poses with Elmer Zook after Zook won the 1937 Midwest Open Soaring Meet in Empire at the Sleeping Bear Dunes. Zook's endurance flight of nearly 11 hours, along with his altitude performance, earned him the American Business Club (A. B. C.) trophy. In all, pilots accumulated 162 hours and 42 minutes in the air, and seven pilots, including one woman, earned their C licenses.

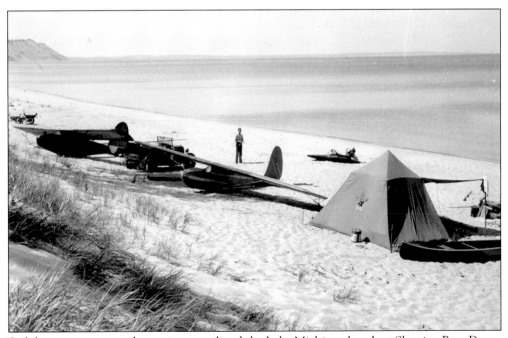

Sailplanes, tow cars, and camping tents lined the Lake Michigan beach at Sleeping Bear Dunes in 1936 in a photograph taken by soaring pioneer Arthur B. Schultz.

Arthur Schultz uses a flag to signal the start of a sailplane tow by automobile on the Lake Michigan beach. The actual average hours per glider in the air per day of the 1936 Midwest Open Soaring Meet, which lasted nine days, was .988 compared to .965 for the 16-day National Soaring Meet at Elmira, New York, that year.

Randall Meeker flew his Detroit Gull primary glider at the Midwest Open Soaring Meets at Empire in 1936 and 1937 and at Frankfort's American Open Soaring Meets the following two years.

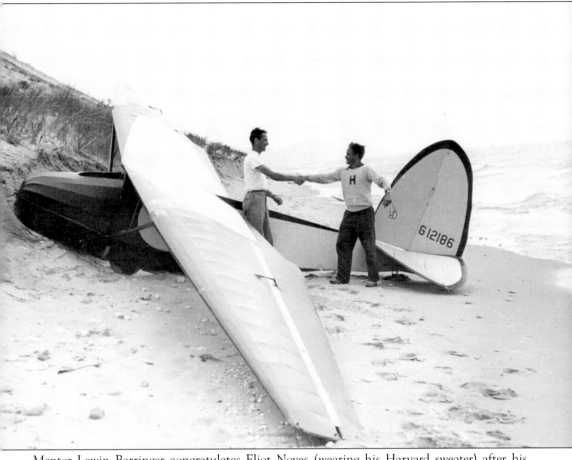

Mentor Lewin Barringer congratulates Eliot Noyes (wearing his Harvard sweater) after his five-hour flight at Sleeping Bear Dunes in September 1937. A year later, Barringer would travel from Philadelphia to visit Noyes in Intervale, New Hampshire. The purpose of the visit was to investigate the possibility of soaring in the vicinity of New Hampshire's White Mountains. The two spent an enjoyable weekend flying around the mountains. Barringer's account in *Soaring* magazine would help provide yet another excellent site to soar.

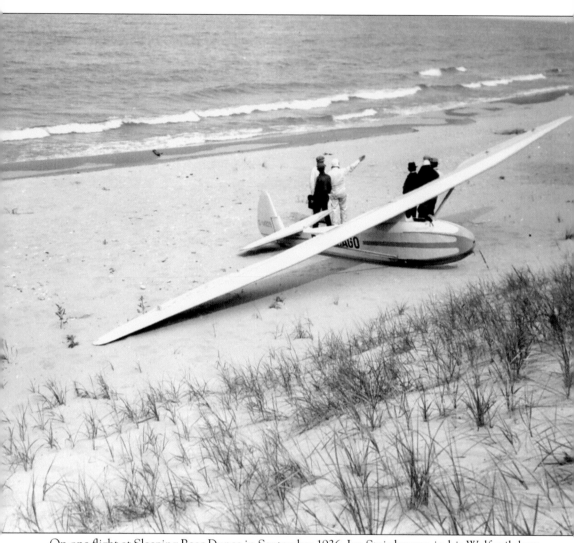

On one flight at Sleeping Bear Dunes in September 1936, Joe Steinhauser, in his Wolf sailplane, took off at 9:40 a.m. and using ridge lift remained aloft until 3:52 in the afternoon.

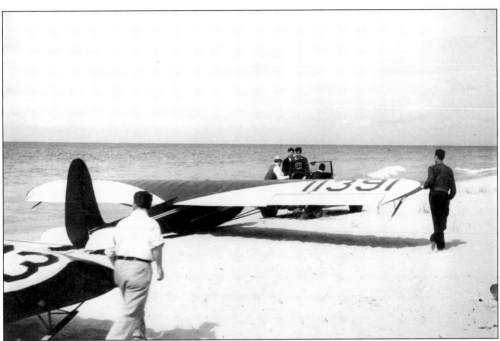

Glider pilots steady the wings of a sailplane ready to be towed by a roadster. Cornell's Udo Fischer (wearing his college sweater), who won the 1936 meet, can be seen just behind the automobile.

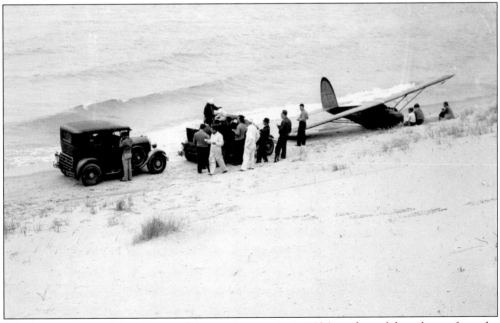

Weather conditions delayed some of the soaring activity in 1936 as a frontal disturbance from the northwest with storm warnings was being reported from the Coast Guard station. Dr. Wolfgang Klemperer instructed the two pilots to watch for a flag signal parallel to the coast, which would indicate a 180 degree shift of wind. Within 20 minutes, Klemperer displayed the signal—"flag across the beach" indicating immediate approach of the front. The ships, then in the air, landed within four minutes.

A sailplane sits calmly on the Lake Michigan beach near Empire, a small village at the base of the Sleeping Bear Dunes. Empire received its name from a boat, *Empire*, which became ice-bound in the harbor in the winter of 1863. During their first glider expeditions to Empire in 1935, Detroit businessmen stayed at Taghon's Inn. Charles and Louise Taghon had come to the area from Belgium and later purchased a gas station and then expanded to include rooms, meals, and a tavern. The gas station is still run by the Taghon family. From 1950 to the early 1970s, Empire was home to the Empire Air Force Station, part of the Air Defense Command, which stood watch over America's skies during the Cold War.

Three

THE SILENT WINGS OF GLORY
1938–1939

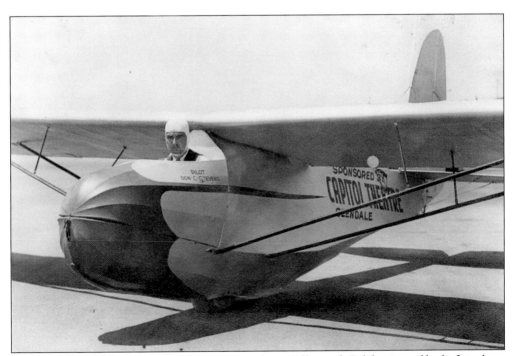

Don C. Stevens (above), like Stan Corcoran, was from Hollywood, California, and had a flair about him. There were only 27 glider pilots in America to obtain their Silver Soaring Badge before 1940. Stevens was number 23, and Frankfort's Corcoran and Ted Bellak were 13 and 14, respectively.

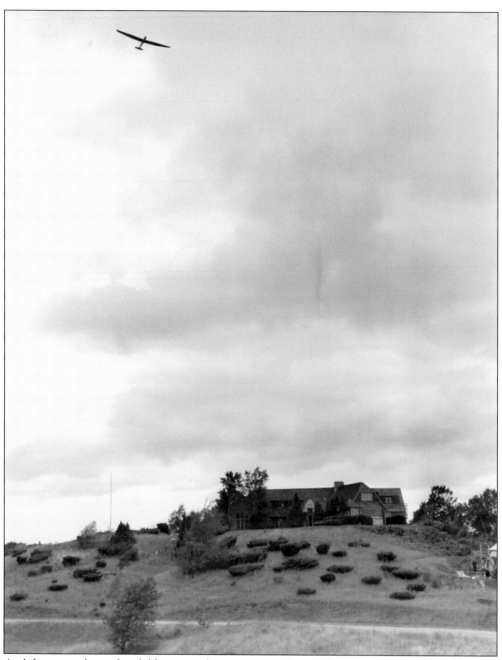

A glider soars above the clubhouse at the prestigious Crystal Downs Country Club golf course north of Frankfort during the late 1930s. Alister MacKenzie designed Crystal Downs in 1933. MacKenzie was one of golf's greatest architects, also designing Augusta and Cypress Point golf courses. The 18-hole private course was rated eighth by *Golf Magazine* in 1997 in an article "Top 100 Courses in the United States."

J. J. "Jim" Smiley, who spearheaded the promotion for the national meets in Frankfort in 1938–1939, explained how things came about in those days, "See what happened . . . Dick duPont's father financed soaring. He gave Lewin Barringer $1,500 to go to Sleeping Bear Dunes and start a meet. Well, Lewin came down to Frankfort and ended up with Leon Rose, the banker. Hugh Gray and Jim Cook of the West Michigan Tourist Association were up from Grand Rapids in the spring of 1938 and I got a telephone call from Leon, who had Hugh and Jim in his office, to come down to the bank and before the afternoon was over, I was chairman of the glider meet. I got everyone a ride in a glider. See, we all belonged to the Rotary Club and we met every Wednesday at noon and everything got settled at the Rotary Club. That's how Frankfort got hooked on gliding. It was there that we discussed getting Stan (later that year) to start the school and buy a glider."

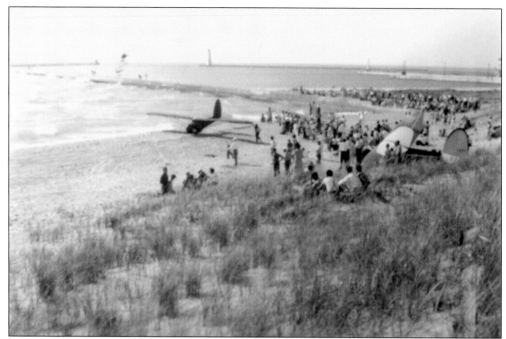

A sailplane gets ready to take off during the national meets of the late 1930s on the Elberta side. Note the Elberta pier and in the distance the Frankfort pier and its lighthouse. There was no charge to the many spectators that lined the beaches and hills to watch the events in those days.

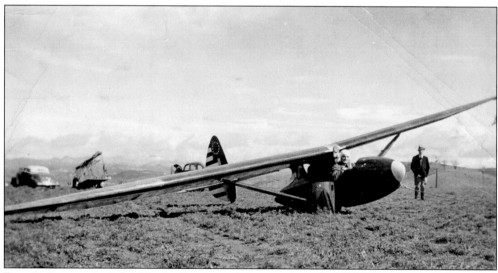

Don C. Stevens sits in his Hawley Bowlus sailplane in the early 1930s. Stevens, Stan Corcoran, and Jay Buxton, all from Hollywood, California, traveled to Elmira, New York, in July 1938, with Corcoran's Cinema sailplane to compete at the national championships. Corcoran and Stevens would eventually end up with the Frankfort Sailplane Company. Corcoran captured second place in the distance event at Elmira, winning a beautiful Bendix Corporation trophy.

DON'T MISS——

THE TIME OF YOUR LIFE!

at the

2nd Annual American Open Soaring Meet

combined with the

4th ANNUAL MID-WEST SOARING MEET

Frankfort, Michigan - August 26 thru Sept. 4

SWELL SOARING – PRIZES — ENTERTAINMENT

Sponsored by Soaring Society of America and Frankfort Chamber of Commerce
Sanctioned by National Aeronautics Association

$1500 in Cash to be distributed on the Logarithmic points award scale – –

Everyone gets his cut ! ! !

ALL FREE TO VISITING PILOTS AND CREWS

FISH BAKE – – – AUGUST 29
DANCE – – – AUGUST 30
BEACH PARTY – SEPTEMBER 2
AWARD BANQUET – SEPTEMBER 4

Lodgings furnished free to capacity of Pt. Betsie Station.
First come – First served. So let us know soon!

DUNE SOARING – NEW THERMAL SITE – AIRPLANE TOWS

Pilots under 21 years of age must bring parents written consent!

By the time the Second Annual American Open Soaring Meet began, Frankfort had received national publicity in *National Geographic*, *Life*, *The Rotarian*, *Saturday Evening Post*, and even the front page of the *New York Times*. The town had come up with $1,500 in prize money for the event, which also featured a fish bake, a dance, and a beach party—all staples of future soaring meets held in the area. Longtime commercial fisherman Ole Olsen was in charge of the fish bake.

49

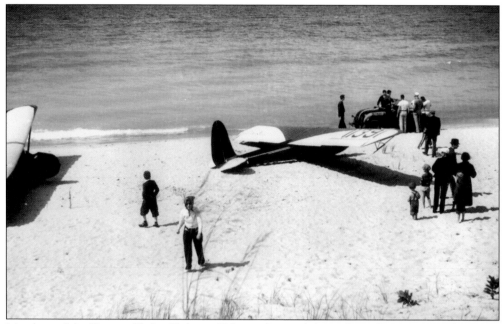

Members of the Detroit Glider Club would bring their sailplanes from the city to northwestern Michigan. During the 1930s, the sport of soaring was pushed to Washington, D.C., when Col. Charles A. Lindbergh said before a House Military Affairs subcommittee, "You should promote interest in gliding. In Germany, glider clubs are all over the place."

Robert Peter Denton was one of Frankfort's original glider club members in the late 1930s. He later was involved with the army air force glider program. He was issued his commercial glider pilot's license on February 17, 1943. On December 2, 2005, in Frankfort, he celebrated his 85th birthday.

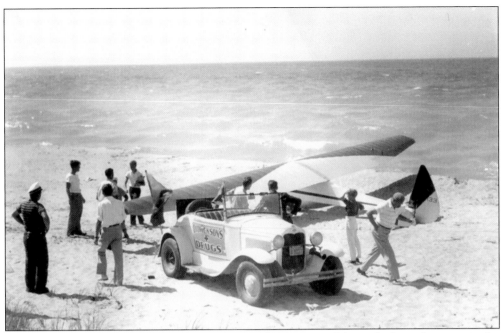

Frankfort druggist Charles Didrickson was an avid supporter of the early days of soaring in the area as seen with the advertising (Didrickson's Drugs) on the tow car as they prepare to launch the Cinema I sailplane.

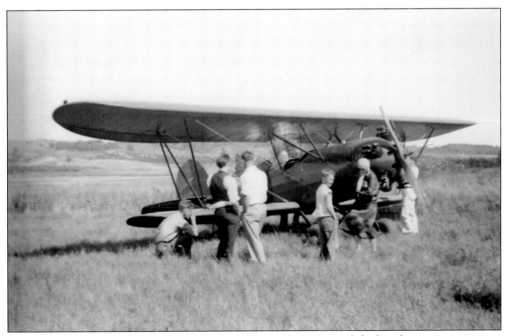

Most tows during the meets of the 1930s were by winch or automobile, but there were occasions at the Frankfort airport where the gliders were towed by an airplane.

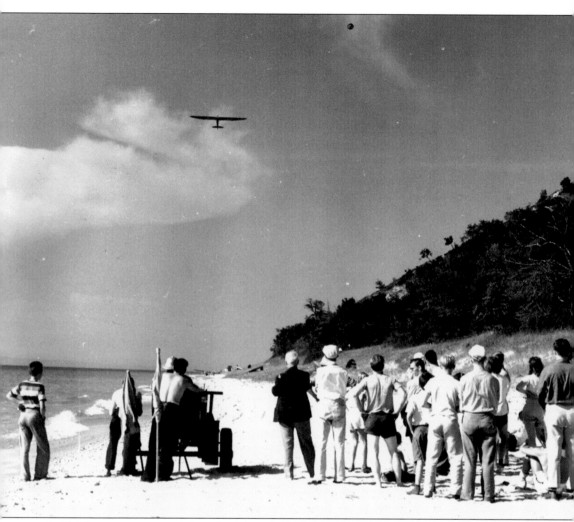

L. D. Montgomery is winch launched from the Frankfort beach during the 1939 American Open Soaring Meet. On this flight, Montgomery thrilled crowds with the longest cross-country flight, soaring at an altitude of 6,790 feet from Sleeping Bear Dunes to Northport, a total of 32½ miles. He won the meet with 161 points, Stan Corcoran was second with 86.

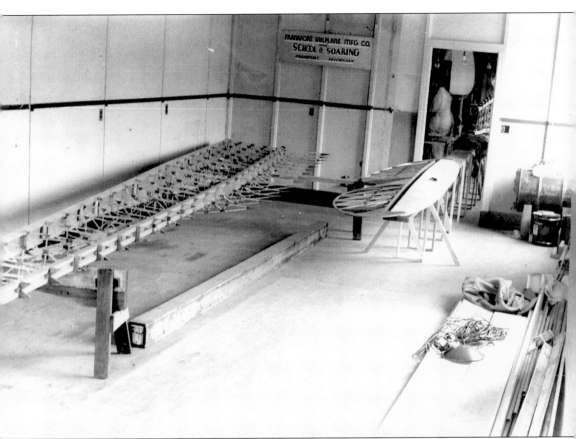

Sailplanes are built in the Frankfort Sailplane Company, which was located on the corner of Fourth and Main Streets in Frankfort. It was one of the three largest sailplane companies in the United States in its time, and the Frankfort School of Soaring was the first such community-backed facility in the nation. In early 1939, the school had a long list of prospective students in addition to the 18 that were already receiving instruction. It was modeled somewhat on the system under which several hundred thousand German youths had been taught the rudiments of flight.

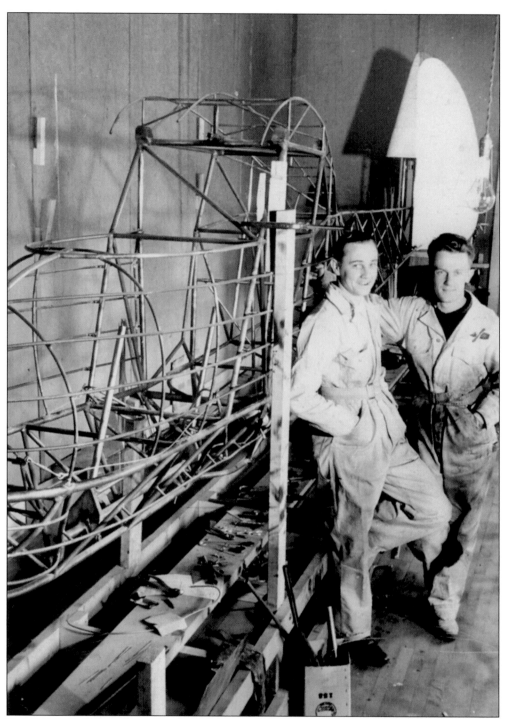

Ted Bellak (left) and Stan Corcoran are photographed in the Frankfort Sailplane Company workshop where they built the Cinema two-place training gliders. Bellak was in charge of building the wings and tail surfaces, while Corcoran built the fuselage, which was made of steel and welded tubing, along with the controls and fittings.

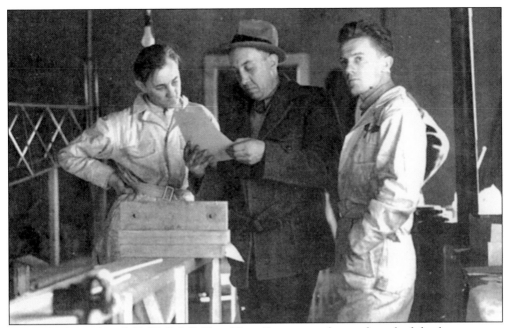

Jim Smiley (center) reads Ted Bellak (left) and Stan Corcoran a telegram from the federal government inviting the Frankfort Sailplane Company to bid on training the first batch of American college students on how to fly gliders in preparation for further training in powered aircraft.

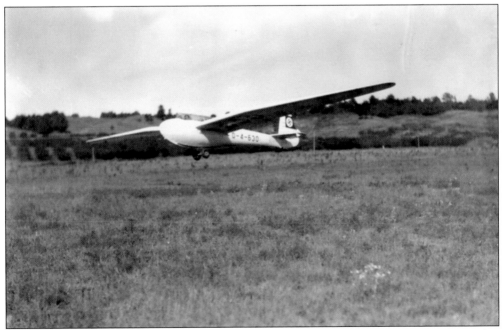

Peter Riedel, shown flying his sailplane at Frankfort in 1938, was the last survivor of the first gliding competition on the Wasserkuppe in 1920. He died quietly in a hospital in Ardmore, Oklahoma, on November 6, 1998, at the age of 93.

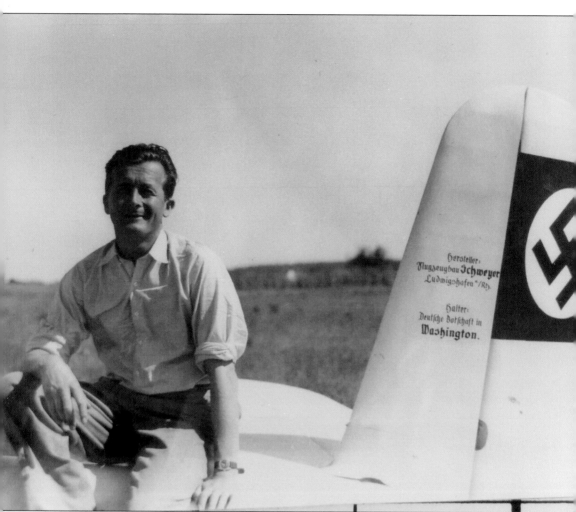

Peter Riedel, a German and one of the greatest soaring pilots in the world, provided the crowds at the Frankfort Airport during the 1938 American Open Soaring Meet with thrills, completing successive loops and barrel rolls. Riedel had started his gliding career in 1920 at the Wasserkuppe. Though he made a strong and pleasant impression on the folk at Frankfort throughout the meet, he agitated the large Jewish population that vacationed in the Frankfort area during the summer. Jim Cook, who began promoting soaring at Sleeping Bear in 1935 while he worked for the West Michigan Tourist and Resort Association, said in a July 1977 interview that "when Peter would fly in his glider with the Swastika emblem on the back, the Jewish people from Cincinnati and St. Louis would mock him. Peter's flights sure did unite the Cincinnati and St. Louis Jews."

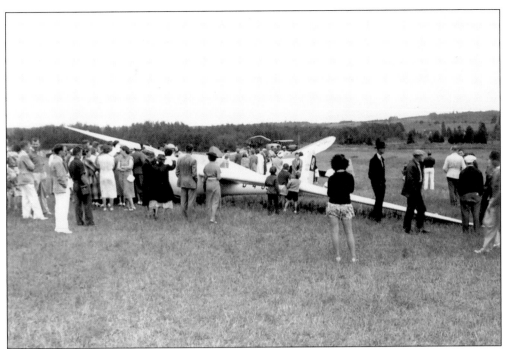

By June 1938, three months before the American Open Soaring Meet at Frankfort, Peter Riedel was installed in the Washington Embassy, and his work in the United States required him to gather intelligence, by legal means and only by legal means, on American air power.

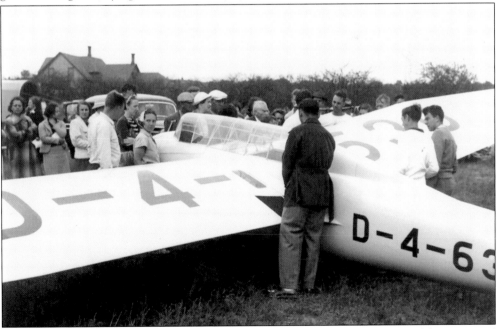

A year before his flights at Frankfort attracted numerous spectators, Peter Riedel was invited by the Soaring Society of America to fly in the 1937 National Soaring Contest in Elmira, New York. He scored more points than any other pilot, although he could not be declared champion since he was not a citizen of the United States.

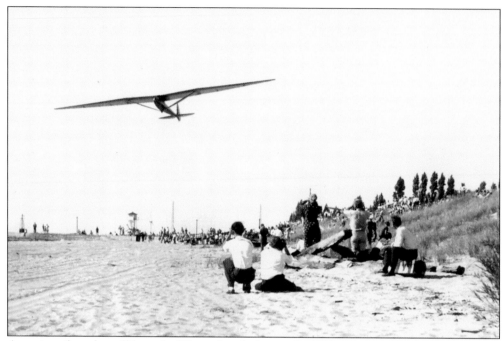

A novice pilot takes off from the Elberta beach during the 1939 American Open Soaring Meet. Elberta, with a population of 500, is located one mile south of Frankfort across Betsie Bay. Originally named South Frankfort, the name of the village was changed in 1911 to Elberta, a variety of a peach grown in the vast orchards of Benzie County. Elberta, for nearly 90 years, was home to the Ann Arbor Railroad and its car ferry system.

The Elberta beach, with its 400-foot bluffs, borders the Lake Michigan waters. Since the first American Open Soaring Meet in 1938, those pilots who ended up in the water were given a vial of Lake Michigan water at the awards ceremony and proclaimed to be members of the Dunker's Club.

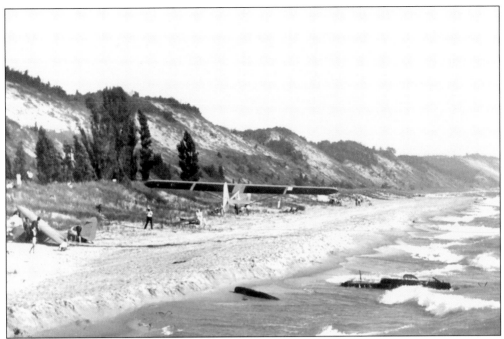

Soaring pilots had flown from the Elberta beach for years, and in 1974, the bluffs to the south of the village were the site of the first major Midwest hang gliding meet. At least one source (a 1956 *Detroit Free Press* article) claims that Octave Chanute came this far north from his original glider experiments in the Chicago area in the late 1890s.

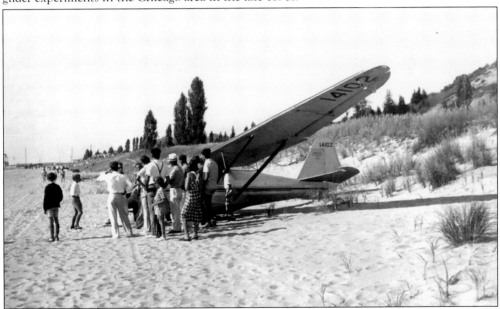

Depending on wind conditions, gliders were launched either on the Frankfort beach, the Elberta beach (above), or from an area known as Benson's field that was inland and one mile south of Elberta on M-22. There were even times in the late 1930s when the pilots discovered thermal soaring on the O'Blenis and Wallaker farms near Thompsonville, about 18 miles to the southeast of Frankfort and Elberta.

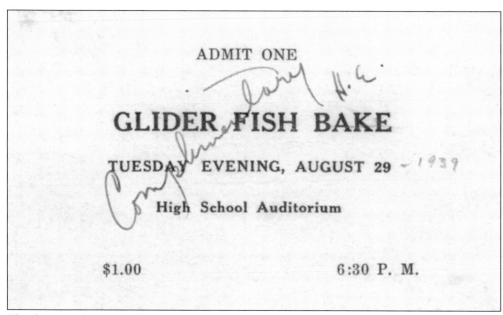

ADMIT ONE

GLIDER FISH BAKE

TUESDAY EVENING, AUGUST 29 ~ *1939*

High School Auditorium

$1.00 6:30 P. M.

The first social event, a fish bake planned at the 1938 American Open Soaring Meet, was a huge success as 175 people were served at the Frankfort school auditorium, and according to the *Benzie County Patriot*, "the broiled fish was never better." Ole Olsen, a master of the art of fish broiling, and his crew prepared the fish outdoors at the rear of the Davis Bakery. Not one piece remained of the 222½ pounds that were broiled. Harry Sutter was the general chef, and Andy Metzger assisted.

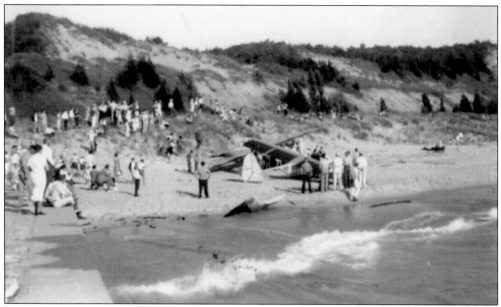

For nearly 70 years now, crowds have gathered on the Lake Michigan beaches to observe motorless flight. During the late 1930s, approximately 30,000 people each year saw the weeklong events of the American Open Soaring Meets, while it was estimated that twice that many were in the Frankfort-Elberta area during the bicentennial year of 1976 to see the soaring and hang gliding activity.

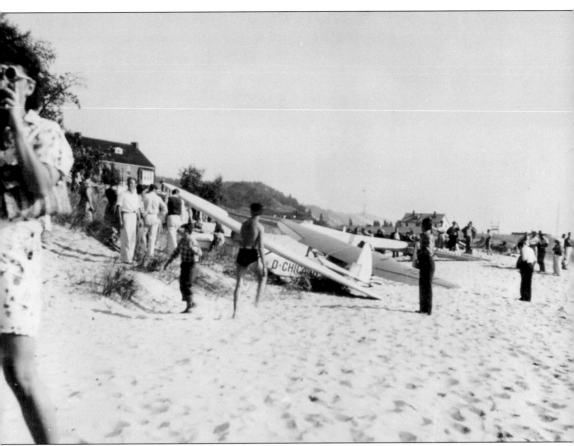

Crowds line the Frankfort beach during the American Open Soaring Meet of 1938 to view the sailplanes. To the far center, one sees the U.S. Coast Guard building (which still stands) that along with the Point Betsie station housed sailplane pilots during the meets and to the left, the Joseph Winkler house. Winkler was head of the musician's union in Chicago in the 1920s, and rumors flew around Frankfort for years that the house had been a hideout for gangster Al Capone.

Women have always been part of the Sleeping Bear Dunes soaring scene. Here Lois Morrissey, one of the early students of the Frankfort School of Soaring, gets a lesson in a glider. Morrissey and Madelyn Frary were featured in a *Life* magazine article in August 1939, while Emma Didrickson Dixon had her photograph in a glider on page one of the *Milwaukee Journal* that summer.

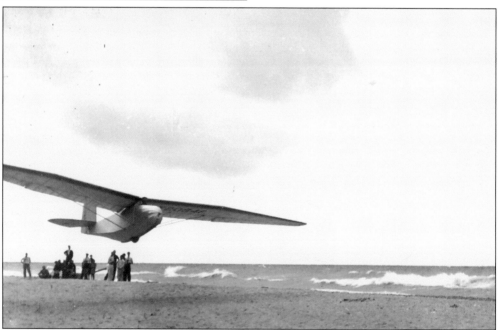

A glider lands on the Lake Michigan beach during competition. One of the safest places to land a sailplane, according to Lewin Barringer, is the beach near Frankfort, Michigan.

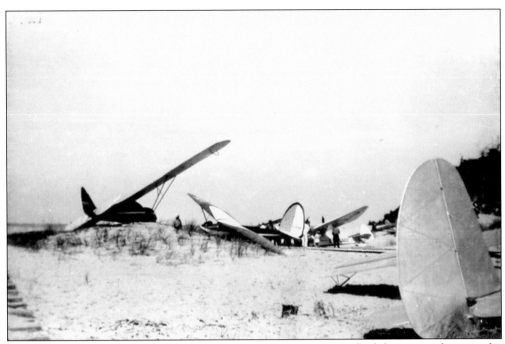

The 1939 soaring meet at Frankfort was a tremendous success, with gliders everywhere on the Lake Michigan beach. Safety was installed as ham radio operators built special equipment to facilitate the running of the meet. The publicity was fantastic. Magazines and newspapers were sending their reporters to Frankfort for stories and pictures. One *New York Times* reporter was the idol of many of the town girls.

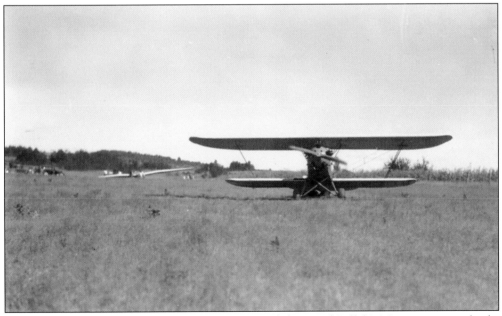

The *Kinner Bird* was used for tows from the airport (where Ted Bellak's Minimoa sits in the far background) and off the beaches.

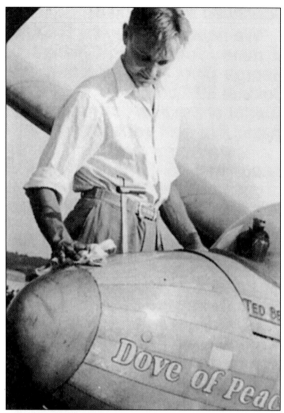

Ted Bellak is pictured with his Minimoa, named the *Dove of Peace*. After the Frankfort businessmen had persuaded Stan Corcoran to stay and start building sailplanes at a glider factory and begin a soaring school in Frankfort, Corcoran sent for Bellak in Newark, New Jersey, to assist him. Shares of the glider factory sold at $50 to anyone interested, and the company became incorporated for $15,000, with all the stock subscribed. With the factory and the school both up in operation, the everyday word became gliding. When a Frankfort businessman was late for dinner, his wife only shrugged and said, "Must be a good soaring day." The truant officer had learned to make a daily scrutiny of the glider field.

The Frankfort School of Soaring in 1939 featured, from left to right, instructor Stan Corcoran, James Smiley, George Bennett, John House, Bill Upton, Carol Anderson, and William Brower. Other early members included Lois Morrissey, Charlie Didrickson, Emma Didrickson, Madelyn Frary, E. R. Luedtke, Cyril Bennett, Robert Denton Jr., Ralph Dixon, George Dayton Hardy, Dr. Fred Thacker, Dale Mix, Laurence Kinne, and Roland Hull.

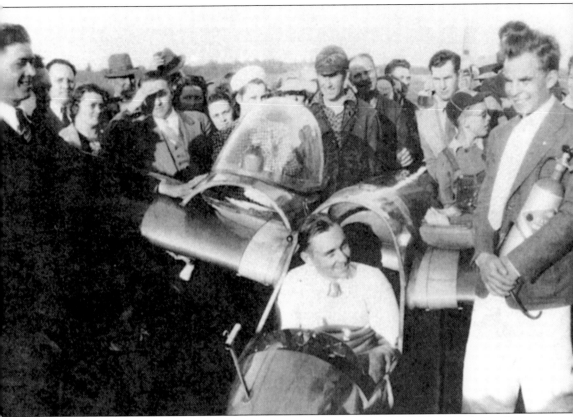

After successfully flying over 57 miles of Lake Michigan on June 13, 1939, from Sturgeon Bay, Wisconsin, to Frankfort, Michigan, people streamed out to the airport to watch Ted Bellak's landing. Vic Saudek is at the right holding Bellak's oxygen tank.

Bellak Set World Over-water Gliding Record on Monday

GREETED BY CROWDS ON ARRIVAL AT AIRPORT

So closely resembling a gull in the clouds that at first the waiting crowds failed to recognize it, the Dove of Peace, the glider piloted by Ted Bellak, made its appearance over the local airport Monday evening at exactly 6:56 EST, setting the world's record for over water soaring and bringing to Bellak and his associates and to Frankfort world wide publicity.

Because of the inclement weather the flight which was originally scheduled for Sunday, was necessarily postponed. Monday morning the weather was overcast and it looked as if the trip would not be possible even then. At four o'clock the ceiling began to raise and the visibility became unlimited. The weather had lightened at Sturgeon Bay earlier in the afternoon and Bellak was awaiting favorable word from this side before making definite plans.

The telephone wires were kept hot checking the weather and wind conditions and explaining last minute details. The wind which had been blowing a gale out of the west had switched to the northwest and was still blowing strong at a high altitude.

Cass Szmagaj, chief test pilot for the Stinson Aircraft Corporation, who had been forced down at South Bend by the storm of Saturday evening on his way to Sturgeon Bay,

The *Benzie County Patriot* only carried a two-column headline of Ted Bellak's world record soaring over Lake Michigan. The *Chicago Tribune* ran six straight editions (second through seventh and final) using eight column banner headline the entire day of the flight. Paramount Newsreel was also at the airport to film the landing.

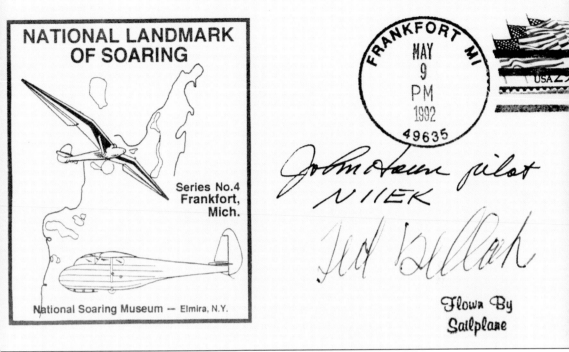

Fifty-three years later, in 1992, Ted Bellak would ride as a passenger with pilot John House in a National Soaring Landmark ceremony delivering the special envelopes (glider mail) to Frankfort postmaster Janet Arnold.

This is to certify that this Cachet was delivered to Ted Bellak, _____ at the Door County Airport, Sturgeon Bay, Wisconsin, to be carried across Lake Michigan in his Sailplane, the "Dove of Peace," inaugurating the first cross water motorless flight ever attempted from Wisconsin to Michigan, across Lake Michigan.

Signed. _Earl M. LaPlant_

This is to certify that this Cachet was delivered to me by Ted Bellak upon the completion of the flight of the "Dove of Peace" across Lake Michigan, from Sturgeon Bay, Wisconsin.

Signed _Rose Smith_

On three known ceremonial occasions, mail has been flown by gliders in the Frankfort, Michigan, area. On September 1, 1939, it was flown in Stan Corcoran's Cinema II along with the Beulah postmaster Clifford Eastman from Frankfort to Traverse City. The mail was part of the Seaplane Base Dedication in nearby Beulah. According to newspapers at the time, it was the "first official free flight of a glider with United States mail in history." Just three months earlier when Frankfort pilot Ted Bellak in his German Minimoa glider took off from Sturgeon Bay, Wisconsin, after being towed to an altitude of 16,500 feet on June 11, in an effort to set the record for the longest over-water (Lake Michigan) glider flight, Bellak carried a satchel of mail. The legal-sized envelopes (shown above) were imprinted for this event and notarized by Rose Smith upon deliverance at the Frankfort airport.

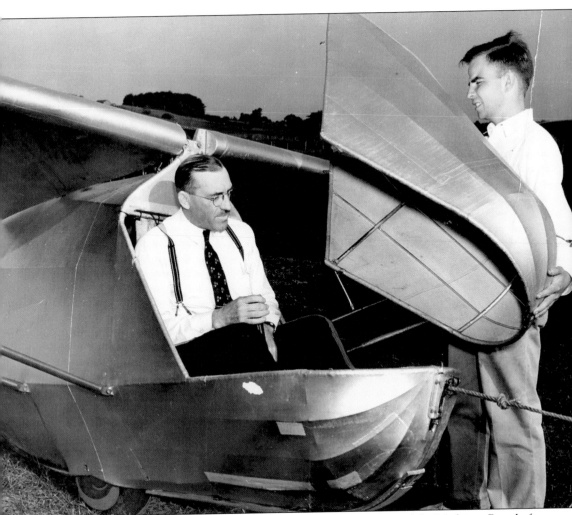

After 23 years of flying power planes, Col. Floyd E. Evans, the director of the Michigan Board of Aeronautics, began his training for a glider pilot's license during the 1939 American Open Soaring Meet at Frankfort. Here Vic Saudek, engineer of the newly formed Frankfort Sailplane Company, gets Colonel Evans ready for a glider flight. Saudek, who just weeks earlier had heard "through the grapevine that Frankfort would definitely receive a grant to teach government-sent students to soar", had taken the first train from the Carnegie Institute of Technology, leaving without waiting for his commencement exercises, to take the engineer's position. In 1939, Michigan had 532 airplanes and 959 licensed pilots, ranking seventh in the United States. They led the nation with 28 gliders.

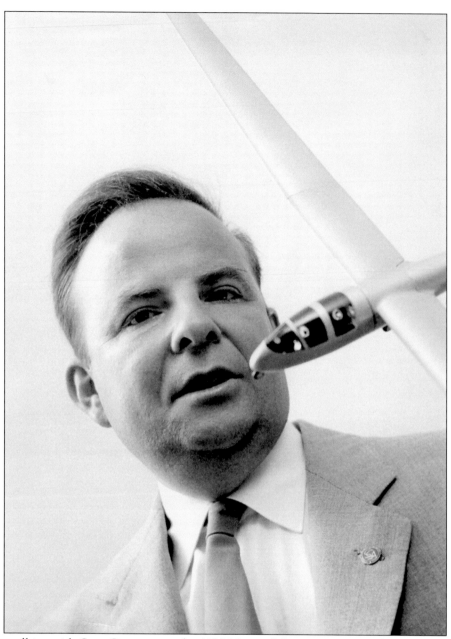

After talking with Stan Corcoran at the 1938 National Soaring Meet in Elmira, New York, 22-year-old Victor Saudek hitchhiked to Frankfort for their American Open Soaring Meet and quickly hooked on as the meteorologist and barographer for the contest. Saudek had crewed at the 1933 and 1935 nationals and was a meet official for the 1936, 1937, and 1938 championships in Elmira. Because of his involvement with the Frankfort meet, he was able to land a position with All American Aviation (now U.S. Airways), Richard C. duPont's airline company that had gained prestige with their short-hop, mail-carrying business. By the mid-1950s, Saudek (above) was the supervisor for the Sierra Wave project, a U.S. Air Force–funded field study of mountain waves. The principal research tool during the Sierra Wave project was an instrumental sailplane tracked in flight from ground by a network of photo-theodolites.

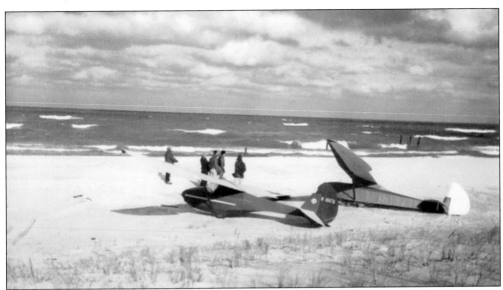

As early as October 1936, an informal soaring meet was held near Benton Harbor, Indiana, with members of four glider clubs participating. It led to the formation of the ChicagoLand Glider Council, a not-for-profit organization intended to encourage motorless flying by sponsoring regional contests, setting soaring records, and aiding sailplane construction. Headed by German-born Chicagoan Joseph P. Steinhauser and Bob Blaine, the editor of the *Air Bubble*, the mimeographed publication of the council, the group was very active in meets at Frankfort in 1938 and 1939. In February 1939, they sponsored a Winter Get-Together and Soaring Forum at the Hotel Sherman in Chicago, with Frankfort's Stan Corcoran and Ted Bellak as the guest speakers. About 200 pilots attended. In November of that year, they hosted a meet at Benton Harbor.

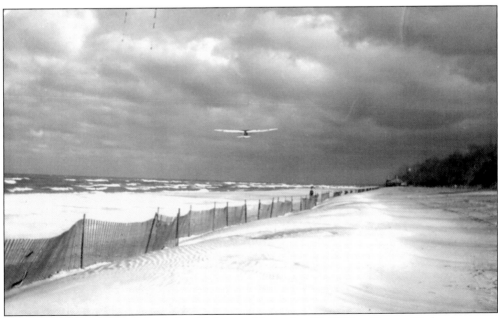

A sailplane takes off amid the dark cold skies on November 12, 1939, at Benton Harbor in a meet attended by Frankfort pilots and hosted by the ChicagoLand Glider Council.

71

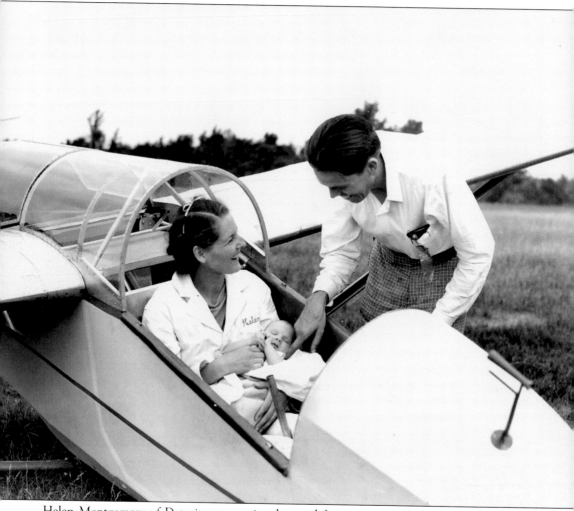

Helen Montgomery of Detroit set a national record for women at the 1938 American Open Soaring Meet, staying aloft for seven hours and 22 minutes. Her time broke Allaire duPont's record of five hours and 15 minutes. The presence of her two-month-old daughter, Mary Helen, who required feedings every four hours, made it impossible for to attempt any endurance records the following year. She delighted the crowd instead by giving Mary Helen a glider ride. Her husband, L. D. (right), had the longest cross-country flight recorded at the 1939 meet.

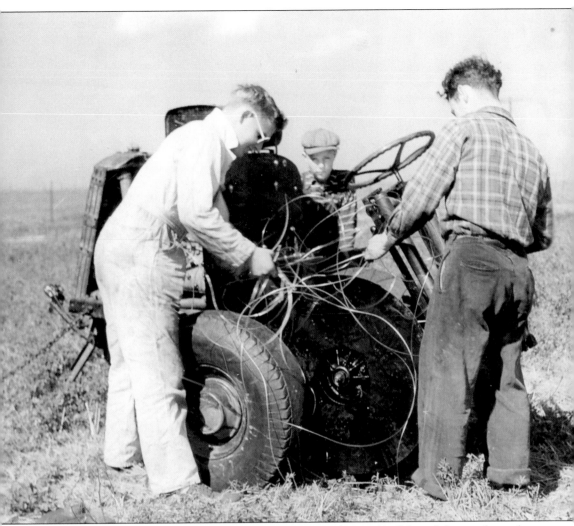

Stanley "Porky" Johnson (left) untangles wire from a winch in 1939. Often gliders in the early years at Frankfort were launched using a stationary ground-based winch, sometimes mounted on a heavy vehicle. The engine is usually mounted from a large car or a diesel truck through hydraulic fluid engines, and electrical motors are sometimes used. The winch pulls in a 1,000- to 1,600-meter-long cable made of steel wire that is attached to the glider. The glider releases the cable at a height of 400 to 500 meters after a very short and steep ride. Johnson was winch operator and mechanic around the Frankfort soaring scene for nearly 50 years. He also went with Stan Corcoran to Illinois when the Frankfort Sailplane Company moved its operation. A photograph of Johnson assembling a sailplane was featured in an article "Training the Glider Army" that appeared in the May 1942 edition of *Popular Mechanics* magazine. When the Frankfort-Elberta area began their National Soaring Festivals starting in 1973, Johnson was the festival's first parade marshall.

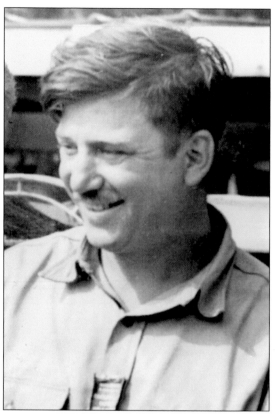

Described as "America's Original Screwbird" in the October–November 1940 issue of *Soaring Magazine*, John Nowak of Toledo, Ohio, epitomized the hospitality and good times that greeted soaring pilots from around the United States when they visited the Frankfort-Elberta area for competitive or informal meets. The magazine went on to state "Johnny will be remembered as the star performer for the benefit of the customers at the American Open Soaring Contest."

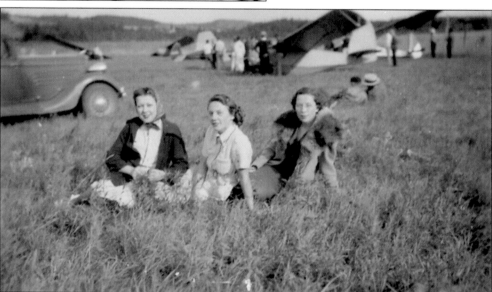

These three Frankfort young ladies in the 1930s, from left to right, Elaine Watson, Carol Anderson, and Jo Rose, were enthralled with those "magnificent men in their flying machines" and like many other area residents, were at the Frankfort airport daily to see the gliders. One pilot that caught the attention of most of the girls was a dashing 23-year-old red-haired pilot from Hollywood, California—Stan Corcoran.

Members of Frankfort's first soaring group, the Frankfort Glider Club, included, from left to right, George Dayton Hardy, who worked on the car ferries; J. J. "Jim" Smiley, who ran the lumber and coal yard; and Dr. Fred Thacker and Ralph Dixon, who owned the dry cleaners. The club was formed in the summer of 1938, and by the spring of 1939, these four men all had their C badges. The club flew year round, and this photograph was taken in the winter on Crystal Lake, north of Frankfort.

Dr. Wolfgang Klemperer (right) and Victor Saudek, in a Pratt Read LNE-1 sailplane, were fixtures of soaring in the Frankfort-Sleeping Bear Dunes area during the 1930s. (Courtesy of the National Soaring Museum)

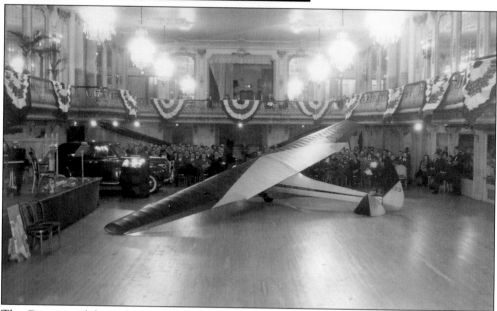

The Cinema sailplane, designed and flown by Stan Corcoran, was the centerpiece of the 1939 ChicagoLand Glider Council exhibit held in the Hotel Sherman in Chicago. Corcoran was from Hollywood, California, resulting in the movie land name of his glider. Corcoran restored his original Cinema and before his death in 1991, donated it to the Smithsonian Institute in Washington, D.C., where it is on display.

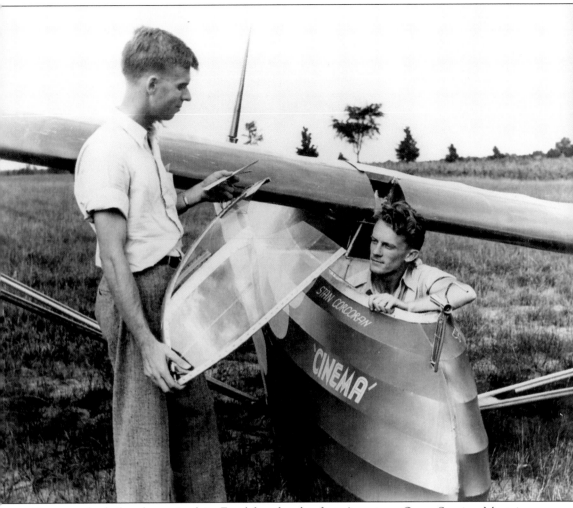

Two months before he arrived in Frankfort for the first American Open Soaring Meet in Frankfort in 1938, Stan Corcoran was in the spotlight at the Ninth Annual National Soaring Meet at Elmira, New York. Competing against the likes of former national champions Richard C. duPont, the millionaire sportsman from Wilmington, Delaware, and Stanley W. Smith, Corcoran had the longest distance flight of 183 miles, soaring from Elmira to Havre de Grace, Maryland. His presence at the Frankfort meet along with others that had participated in July at Elmira gave the meet a real national flavor. At the end of the meet, he was in his vehicle with his glider and trailer and headed out of Frankfort when lumber yard owner J. J. Smiley, who was in charge of promoting soaring in the town, lured Corcoran into staying and setting up a school to teach the sport. "Damn you, Jim, I was almost out of town headed for Texas to become the first pilot ever to obtain the Gold Badge," Corcoran retorted to Smiley at a banquet in Frankfort in July 1977.

Two of the early promoters of soaring at Frankfort-Elberta were glider pilot Stan Corcoran (left) and meteorologist Vic Saudek. Saudek also became the chief engineer for the Frankfort Sailplane Company, one of three recognized glider factories in the United States in the late 1930s. Saudek had hitchhiked from the Carnegie Institute of Technology in Pittsburgh in 20 hours to help with the 1938 meet, stopping in Dayton, Ohio, to visit with Orville Wright. "Mr. Wright, why did you return to glider flying in 1911 after your airplane had been successful and proven itself in 1903," Saudek asked. "Well, we have given several answers to different people to that question, that it was to experiment with stability and controls. But you know and we knew then, that it was more fun to fly gliders than it was to fly powered airplanes."

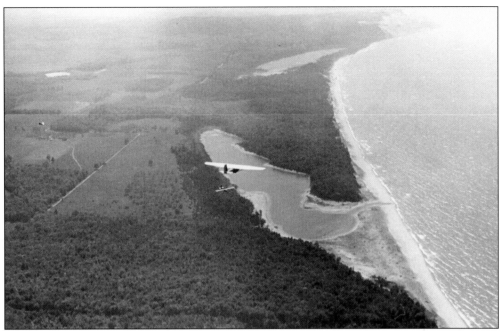

Gliders soar above North Bar Lake near Empire. The ridge soaring off the Sleeping Bear Dunes made it an ideal spot, although changing wind currents during the last few days of the 1937 Midwest Open Soaring Meet saw pilots take their craft to Point Betsie, 15 miles to the south. When a north wind failed to furnish required air currents early on September 5, the meet was moved to the Crystal Downs beach on Lake Michigan. Gliding was in Frankfort to stay. News of soaring in northwestern Michigan spread among America's 900 glider pilots.

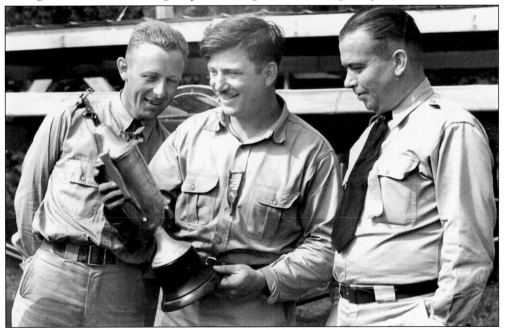

John Nowak (center) admires the trophy given to the top pilot at the 1939 American Open Soaring Meet in Frankfort won by Detroit's L. D. Montgomery.

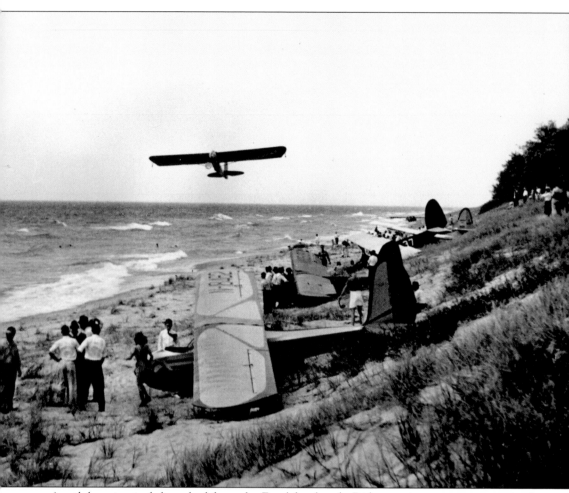

A sailplane is winch launched from the Frankfort beach. Ridge soaring, most common in the Sleeping Bear Dunes area, is of a purely mechanical nature. Air moving with the wind travels horizontally until it meets a vertical barrier. It is then deflected upwards, resulting in areas of lift on the windward side. The uneven heating of the earth's surface by the sun causes convection currents. There are rising columns of warm air or thermals. Glider pilots were able to utilize thermals effectively when a suitable instrument, a variometer, was developed, which would enable pilots to detect the slightest change in climb and sink. By the 1939 soaring meet in the Frankfort area, pilots were heading inland toward the Thompsonville area to thermal soar.

Four

THE WAR YEARS
1940–1945

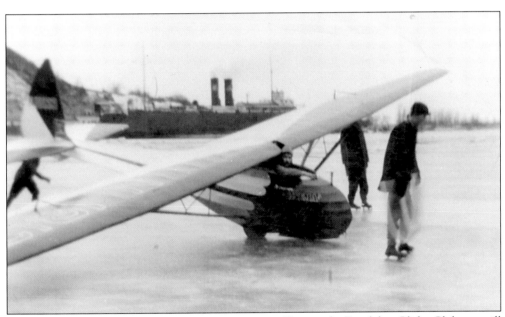

Despite the Frankfort Sailplane Company moving to Illinois, the Frankfort Glider Club was still a social force in the town, holding dances and other benefits. Although minor national meets were held in the early 1940s, the war limited the expert glider pilots from participating. Local soaring enthusiasts like Ralph Dixon, shown walking in front of a glider on December 4, 1942, and the "Flying Doctor," Fred Thacker, enjoyed the sport year round. Although most of the winter soaring was at Crystal Lake, north of Frankfort, they also enjoyed the sport towing off the ice on Betsie Bay, a body of water about one mile wide that separates the city of Frankfort and the village of Elberta. For nearly 90 years, the bay harbored car ferries that carried passengers and rail freight across Lake Michigan to Wisconsin. (Courtesy of Jack Clement)

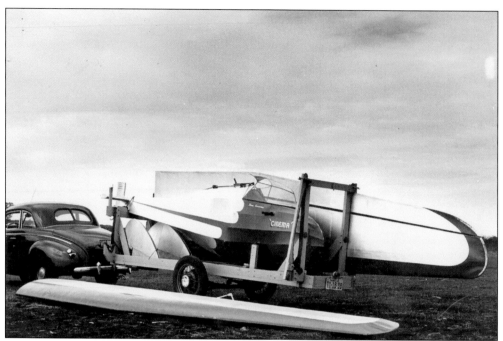

Stan Corcoran's Cinema I sailplane is loaded up on a trailer for transportation to a meet in 1940. Corcoran was second to J. Shelly Charles in the American Open Soaring Meet at Lockport, Illinois. Charles won with 1,034 points, Corcoran had 933, and John Robinson, the second pilot to ever obtain the Gold Badge, had 866.

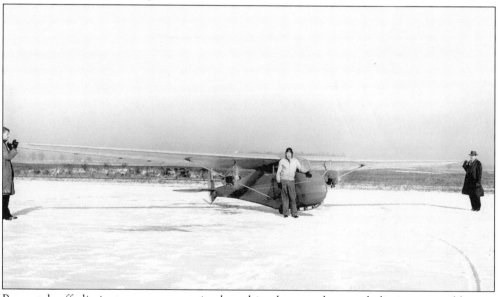

Power takeoff eliminates more expensive launching by tow plane and eliminates troublesome launching by winch or automobile. Stan Corcoran is shown above in a close-up of a powered glider, with the engine idling. Corcoran wrote many magazine articles during the 1940s about the powered glider, and in a November 1944 edition of *Powered Flight* magazine noted, "There is a place for the powered glider in the flying world and it is my belief that the postwar period will see a definite trend in this direction."

After his brief two-year stay in Frankfort, where he helped form the Frankfort Sailplane Company and the School of Soaring along with setting a world over-water soaring record, Ted Bellak became a navy pilot and flight instructor in World War II. He also became director of an aeronautic education program for the state of Minnesota and later helped Colorado establish a similar program of its own. At the age of 61, in 1973, Bellak said "people like me are peculiar. The air holds the same fascination for me as it did 45 years ago. It's the nearest thing to being yourself that you could find because you have to depend entirely on your wits."

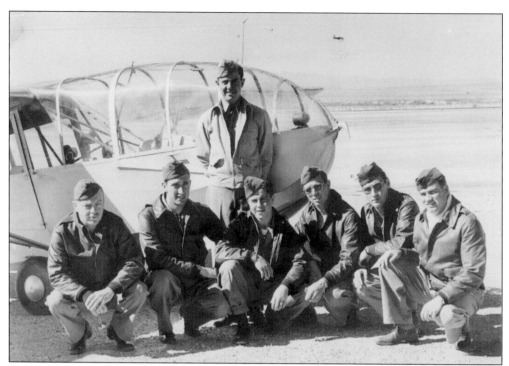

Another civilian glider instructor who learned his soaring at Sleeping Bear Dunes was Chuck
Kohls. At 29 Palms, California, in January 1943, Kohls (standing) was training these six soldiers
in a TG-6A.

Stan Corcoran, in a tense moment, is conducting a static load test as he oversees sailplane
construction with the Frankfort Sailplane Company in Frankfort, Michigan, and Joliet, Illinois.
The company delivered nearly 60 training gliders to the U.S. Army during the early 1940s.

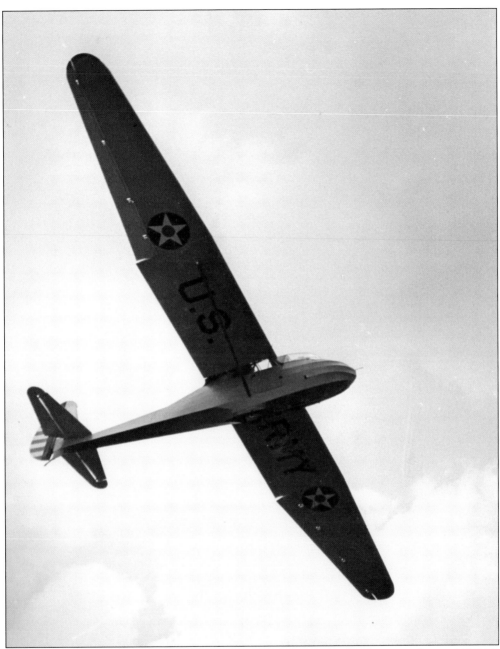

With a wingspan of 46 feet and an empty weight of 500 pounds, the Corcoran-designed TG-1A Cinemas were sold surplus after World War II, and a few are still active in the United States. The original Cinema IIs had small, all-moving tails, but the military TG-1As had conventional tails.

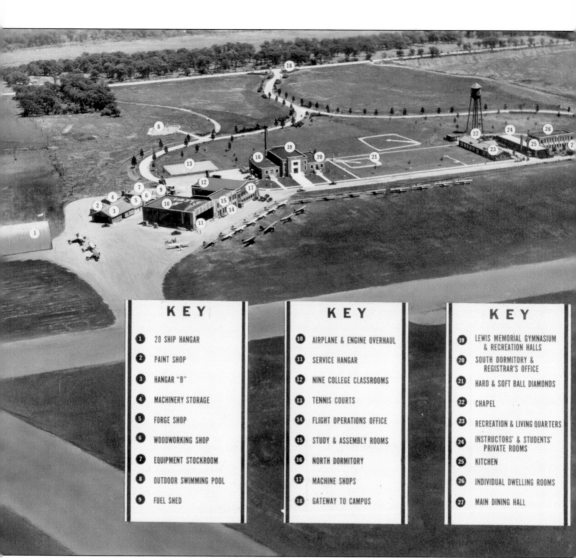

KEY

1. 20 SHIP HANGAR
2. PAINT SHOP
3. HANGAR "B"
4. MACHINERY STORAGE
5. FORGE SHOP
6. WOODWORKING SHOP
7. EQUIPMENT STOCKROOM
8. OUTDOOR SWIMMING POOL
9. FUEL SHED

KEY

10. AIRPLANE & ENGINE OVERHAUL
11. SERVICE HANGAR
12. NINE COLLEGE CLASSROOMS
13. TENNIS COURTS
14. FLIGHT OPERATIONS OFFICE
15. STUDY & ASSEMBLY ROOMS
16. NORTH DORMITORY
17. MACHINE SHOPS
18. GATEWAY TO CAMPUS

KEY

19. LEWIS MEMORIAL GYMNASIUM & RECREATION HALLS
20. SOUTH DORMITORY & REGISTRAR'S OFFICE
21. HARD & SOFT BALL DIAMONDS
22. CHAPEL
23. RECREATION & LIVING QUARTERS
24. INSTRUCTORS' & STUDENTS' PRIVATE ROOMS
25. KITCHEN
26. INDIVIDUAL DWELLING ROOMS
27. MAIN DINING HALL

The tiny operation of the Frankfort Sailplane Company and the Frankfort School of Soaring could not keep up with production work and had financial difficulties, so Stan Corcoran and J. J. Smiley negotiated with Chicago businessmen Phil Wrigley and George Getz to transfer the school and the factory to Lockport and Joliet, Illinois. The Lewis School of Aeronautics was an old, established school with spacious facilities offering training that was fitted to the needs of modern aviation. In 1940, they added the glider training with Corcoran in charge.

George Dayton Hardy poses from the pilot seat of his glider. Hardy, an original member of the Frankfort Glider Club in the late 1930s, became involved with the army air corps gliding program and became a flight instructor at Stamford Flying School in Texas.

In November 1943, two engine installations of six horsepower each were designed to mount on each lift strut of a Cinema two-place glider. As the strut is not braced fore and aft, it was static tested with a load of 600 pounds applied to simulate the engine thrust. Actual static thrust of each engine with 26-inch Contra Rotating Propellers, figured Corcoran, is 37 pounds, which gives an adequate safety factor. Fuel tanks, one for each engine, were mounted directly behind, which also helped the balance.

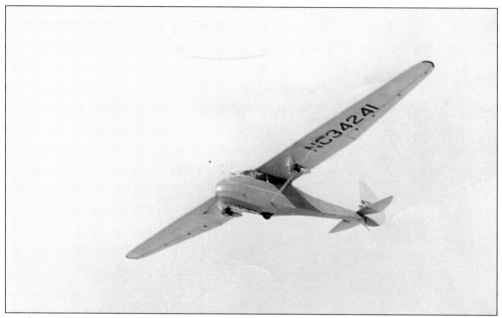

At the onset of World War II, the Army Air Forces needed to train glider pilots to handle the large Waco GC-4A. The first aircraft selected in this role was a glider designed by Stan Corcoran, the TG-1A. With the industry stretched to its limits, Henry H. "Hap" Arnold, Commanding General of the AAF, declared that glider contracts would be awarded only to civilian manufacturing firms not already committed to military aircraft production.

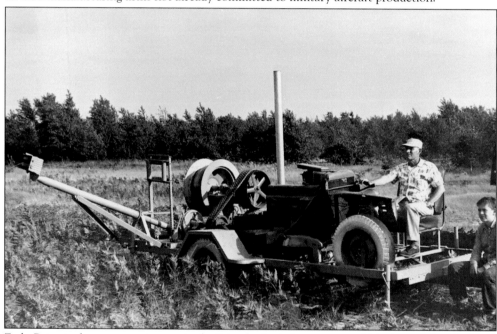

Zada Price is shown operating a winch. Price had tried to get out of his Ann Arbor Railroad position in Elberta, Michigan, during World War II to join the Army Glider Pilot Training program and had written letters to then Maj. Lewin B. Barringer, who headed the Glider Unit of the Air Corps.

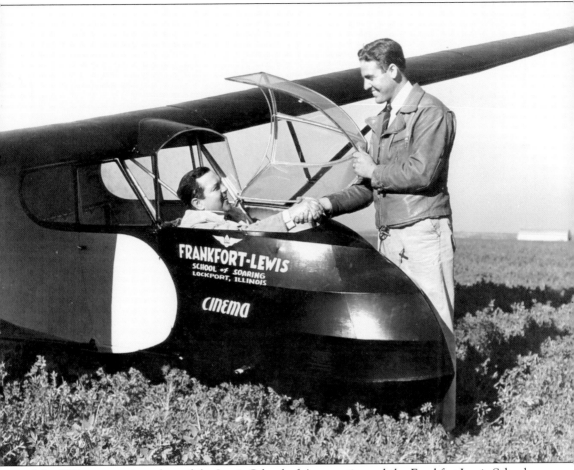

John Wilson, superintendent of the Lewis School of Aeronautics and the Frankfort-Lewis School of Soaring in Lockport, Illinois, sits in a Stan Corcoran–designed Cinema. When the Frankfort Sailplane Company could not meet the capabilities of government contracts to build gliders and train its pilots, the operation was moved to Illinois, where it also benefited from the capital investments of entrepreneurs Phil Wrigley of the chewing gum company, John J. McCormack of the *Chicago Tribune,* and George Getz, who had promoted the Tunney-Dempsey heavyweight title fight at Soldier Field in 1927. In June 1940, the army air corps called a group of pilots and manufacturers from the East and Midwest to Dayton's Wright Field for a hasty conference. A week later, it assigned six officers to the Frankfort-Lewis School of Soaring and a like number to the Elmira, New York, Soaring School for a three-week intensive training course in motorless aircraft.

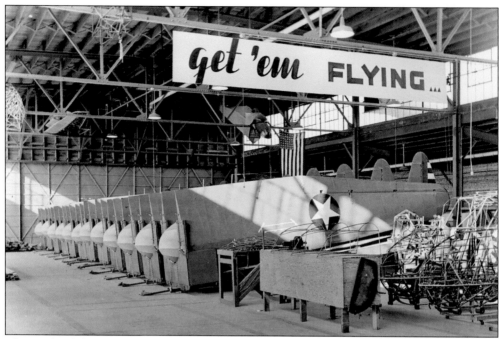

The inside of the Frankfort Sailplane Company in Joliet is shown with the finished gliders and a World War II motto, Get 'em Flying.

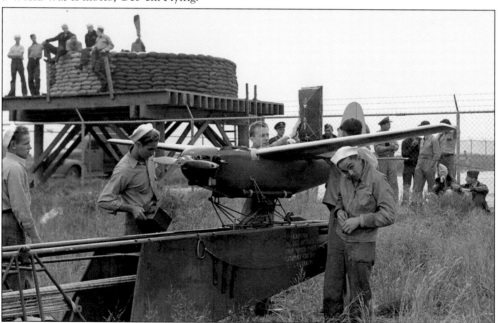

Stan Corcoran's technical flying knowledge was put to many uses during World War II. He is best remembered for his pilot training activities and the production of his Cinema II (TG-1A) for the glider corps. However, he is pictured in the center at a naval base in Cape May, New Jersey, where he designed and tested new model drones, which were used for navy gunnery practice. The small plane (drone) in the photograph would be launched with a catapult and then flown by radio controls from the ground.

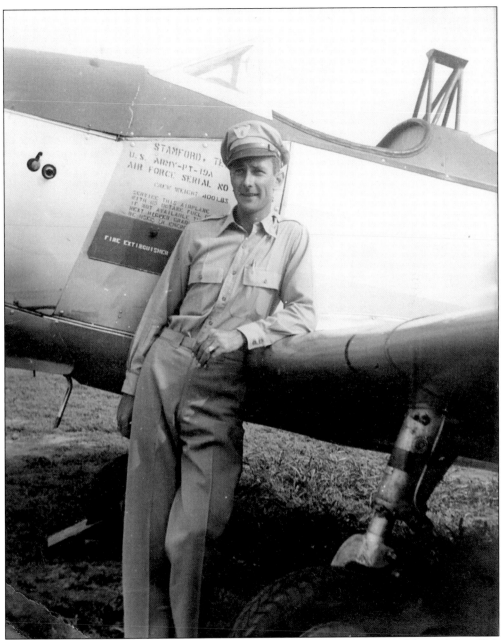

Frankfort's Ralph Dixon, who was among the first members of the Frankfort Glider Club when it formed in 1938, became a flying instructor for the U.S. Army at the Stamford Flying School at Stamford, Texas, in May 1943. When the Frankfort Sailplane Company moved to the Lockport-Joliet, Illinois, area and became a division of Globe Corporation, Dixon and a number of other persons from Frankfort went with it to concentrate on the various government-funded programs.

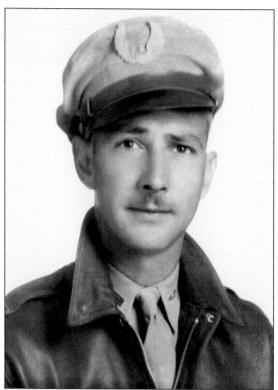

Soaring Magazine reported in its August–September 1940 issue that "although we have not had much news from Frankfort of late, there is still plenty of gliding up there. R. L. Dixon made a cross-country flight of 17 miles in the club's Cinema early in the summer." By the end of the year, Dixon had left for Lockport, Illinois, with the Frankfort Sailplane Company and then to LaMesa Field in Wichita Falls, Texas, and the Stamford Flying School in Stamford, Texas, as an army flying instructor. In June 1942, the U.S. Army purchased the Cinema I from Bob Nickson, Dr. Fred Thacker, and Dixon.

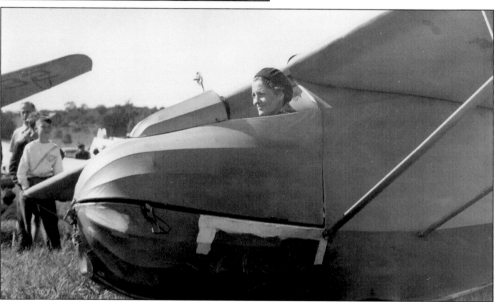

Helen Montgomery thrilled the crowds of the 1938 American Open Soaring Meet at Frankfort, setting a women's world duration record. Two years later, at the 1940 meet held in Lockport, Illinois, and sponsored by the Frankfort-Lewis School of Soaring, she set a new women's distance record of nearly 21 miles, landing east of Cicero in a somewhat difficult terrain just south of the Chicago city limits. She finished in eighth place overall (both men and women). Stan Corcoran had the meet's greatest distance flight of 186 miles to Dolan, Indiana.

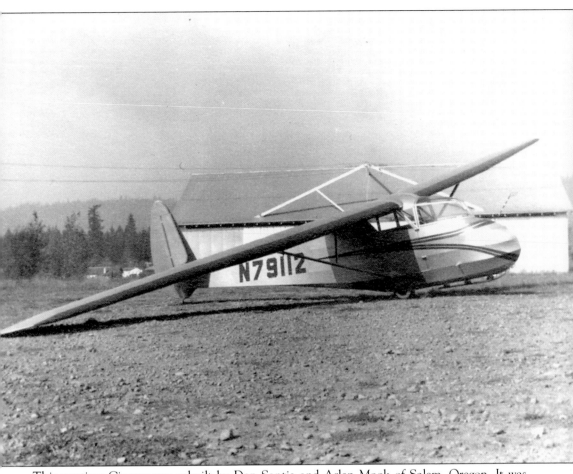

This wartime Cinema was rebuilt by Don Santie and Arlen Mook of Salem, Oregon. It was restored to like-new condition with the exception of the wings, which were brand new. This was one of three Air Force Cinemas taken to Oregon by Richard Laws after the war. The rebuilding was completed in 1958, leaving a 14-year span during which the ship had not been flown. In a letter to Stan Corcoran, the designer of the sailplane, after rebuilding the glider, Santie and Mook reported that "it handled very well."

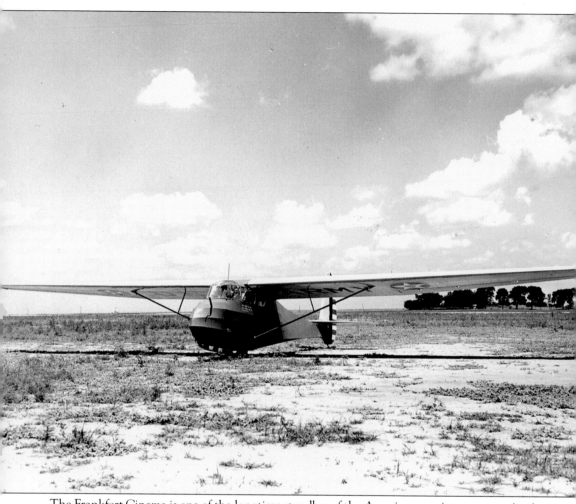

The Frankfort Cinema is one of the longtime standbys of the American soaring scene getting its start in 1938 as a pure sporting sailplane and then serving in the early part of World War II as an army training glider. The original Cinema I was designed by Stanley Corcoran with a single seat along conventional lines. Wings and tail surfaces were built of birch plywood and spruce and the fuselage was welded steel tubing. The horizontal tail consisted of "pendulum" elevators with no horizontal stabilizer, which was as fairly common design feature at the time. A few single-seat models were built and the design was developed into the Cinema II, a two-seater that was built by the Frankfort Sailplane Company. Shortly before U.S. participation in World War II, the army developed an interest in glider operations and invited the industry to submit designs suitable for initial glider training.

Five

REVITALIZING THE SPORT
1946–1960

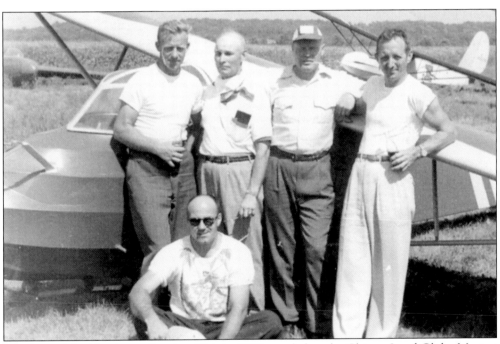

Members of the Northwest Soaring Club in 1956 traveled to the ChicagoLand Glider Meet at Elgin, Illinois. They are, from left to right, Dale Houghton, Zada Price, Maj. Harold Peasley from the Empire Air Force base, and Peter Panos; seated is Eugene J. Hansknecht, who became the club president during the 1970s. During the post-war years, interest in gliders appeared to languish, and the earlier organized Frankfort Glider Club became inactive until 1952, when at the urgent request of the many newly formed gliding clubs in the Midwest, a new association was formed—the Northwest Michigan Soaring Club, Incorporated, with Panos as president and Price as secretary-treasurer.

Harold "Stollie" Larson was a fixture at the Frankfort airport since 1945. An aviation mechanic in the navy, Larson logged between 400 to 500 glider tows each year for decades. His wife Elaine's father, Zada Price, had single-handedly revived the sport of soaring in the Frankfort area after World War II. After Price's death in a glider crash in 1960, the Larsons, according to Elaine, have "pretty much spent our lives out here at the airport."

Sometimes after numerous airplane tows, a pilot needs a little rest. Here Stollie Larson, one of the longtime supporters of the sport in the Frankfort area and an expert tow pilot, takes a nap in the shade.

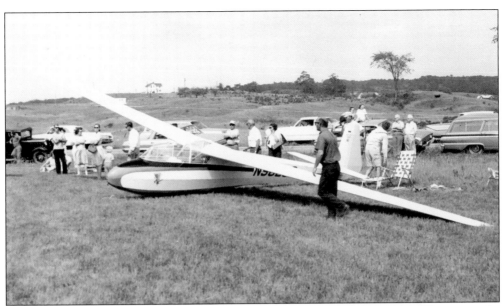

Members of the Vultures Soaring Club were frequent visitors to the Frankfort-Elberta area for meets in the 1950s and 1960s as evidenced by this club sailplane. The Vultures were formed in the early 1950s, flying from Big Beaver Airport in Troy, Michigan. The club moved to Oxford and were there a long time despite having a winch-only operation. But when the location was sold for quarrying, they shared facilities with another Michigan-based club, the Sandhill Soaring Club near Gregory. Since 1994, they have flown from Maple Grove Airport, Almont, and presently Marlette.

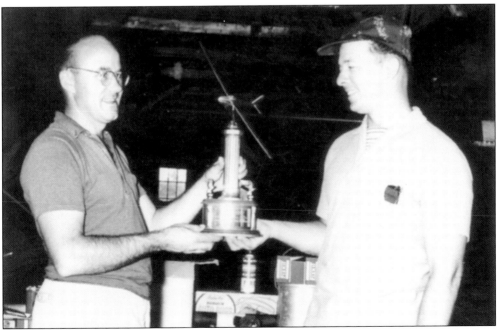

Three-time U.S. Soaring champion Richard Schreder (right) is presented with a trophy from Northwest Soaring Club president Eugene Hansknecht after a meet in the Frankfort-Elberta area.

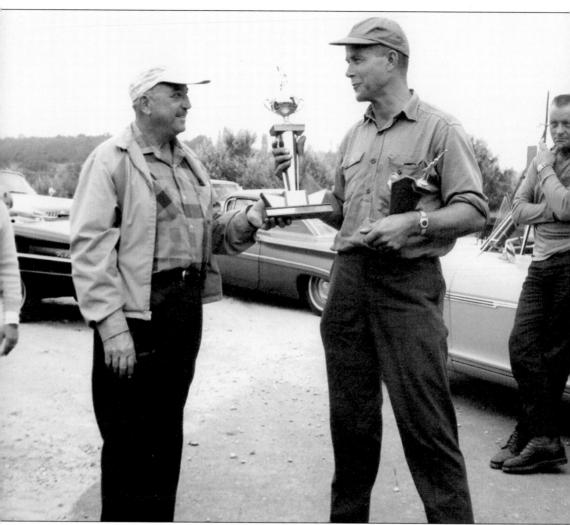

German native Eberhard Geyer (right) receives another trophy from meet coordinator John Nowak in Frankfort in the 1950s. Longtime promoter Stollie Larson (right) watches the presentation. Geyer received his C badge and his glider instructor rating Class II, instructing students in bungee and aerotow launch techniques in pre-war Germany. In 1941, Geyer received his Silver C badge, the last Silver C issued in Germany prior to the start of World War II, when cross-country flights were banned. His historic flight was on September 16, 1941, one day prior to his 19th birthday.

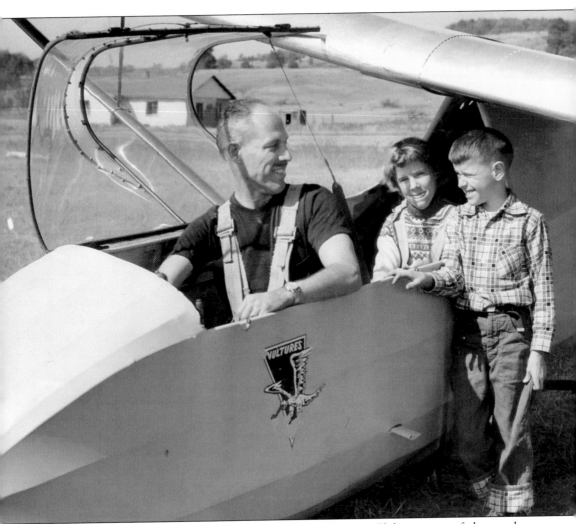

Dr. Harner Selvidge of the Michigan-based Vultures Soaring Club was one of the regulars at Frankfort during the 1950s, giving rides to adults and children alike. Selvidge, a longtime director of the Soaring Society of America (SSA), was awarded the Warren E. Eaton Memorial Trophy in 1960. The trophy is given to a person who has made an outstanding contribution in the art, sport, or science of soaring flight in the United States. Eaton was the founder and first president of the Soaring Society of America. Selvidge later flew out of Sedona, California, where he worked for Bendix Aviation, now Honeywell Bendix/King Avionics.

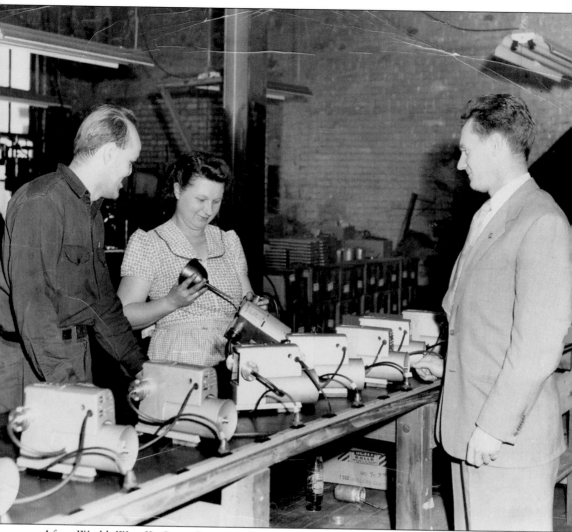

After World War II, Stan Corcoran began a manufacturing company that produced air compressor units. Shown at the inspection table of the R. S. Corcoran Company, from left to right, are Richard Danielson, superintendent; Modesta Sako, inspector; and Corcoran. The compact compressor unit is used in connection with a spray gun.

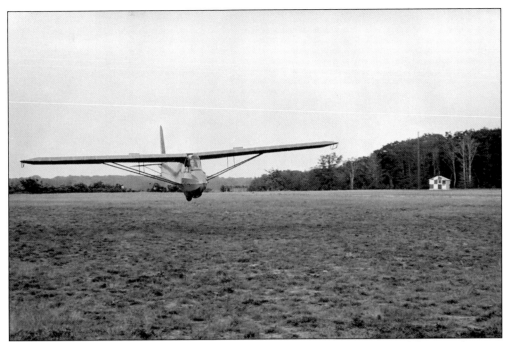

Northwest Soaring Club of Frankfort member Bob Weigand lands his 119 sailplane on the grass runway in 1959.

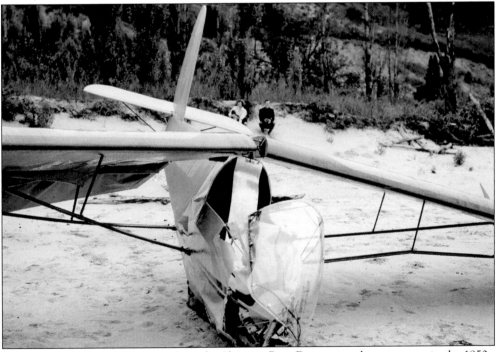

It was very rare for a glider to crash in the Sleeping Bear Dunes area, but at a meet in the 1950s, Toledo's Sam Cochrane suffered cuts to his head and an injured back after his glider fell 700 feet into Lake Michigan near the Elberta beach. Cochrane was coming in for a landing, and when he depressed the nose of his ship it failed to pull out of the dive and landed in four feet of water.

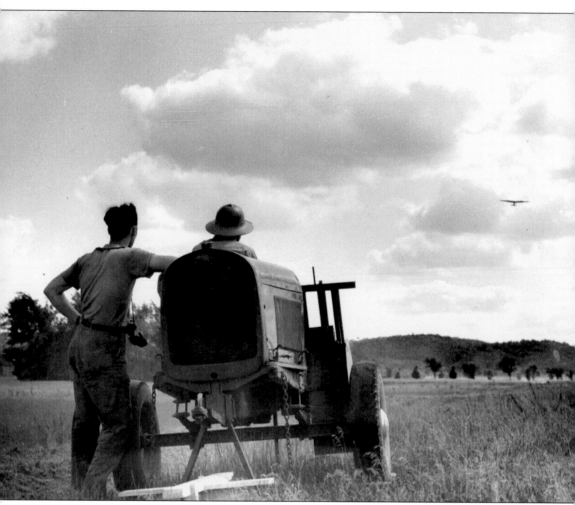

The operation of a winch requires more skill than tow car driving and should be done only by and under the close supervision of someone thoroughly familiar with it. The tow must be started in the gear to be used throughout the tow as the drum does not have enough inertia to permit gear shifting without danger of fouling the line. The choice of gear to be used depends on the power and pick-up of the engine, the gear ratio of the engine to the drum, the weight and the drag of the glider, and the wind velocity. The Frankfort-Elberta area had many capable winch operators including Zada Price, Randy Meeker, and Porky Johnson.

During the 1958 World Soaring Championships at Leszno, Poland, it was fortunate for the U.S. team that John Nowak was along as the crew chief. Nowak, who spoke fluent Polish, was able to speak to the hosts of the meet to transmit their greetings to the team. When the premier of Poland Jozef Cyrankiewicz met the U.S. contingent, it was Nowak who offered greetings to him and proceeded to introduce the team members in Polish.

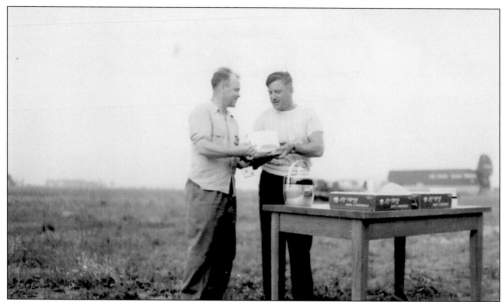

Paul F. Bikle (left), who won the Lewin B. Barringer memorial trophy (awarded to the pilot making the greatest straight-line distance soaring flight) each year from 1952 to 1956, receives an award from John Nowak at the Toledo, Ohio, glider meet in 1950. Bikle and Nowak both were pioneer glider pilots at Sleeping Bear Dunes.

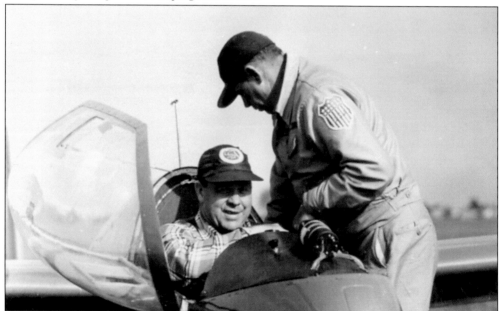

Born in Wilkinsburg, Pennsylvania, in 1917, Paul Bikle began gliding at the age of 19 in a rebuilt Eaglerock Primary at Sleeping Bear Dunes while attending the University of Detroit. Bikle flew a Breguet 901s for the United States team at the World Soaring Championships at Leszno, Poland, in 1958. Gus Briegleb helps him get ready. John Nowak, who flew at the dunes in the early 1930s, served as the crew chief. Lyle Maxey, another pilot whose early days of flying were in the Sleeping Bear Dunes/Frankfort area, was the top finisher for the United States that year, placing ninth out of the 61 contestants.

John Nowak (center) points to the soaring activity on the Elberta beach, a mile south of Frankfort, during an informal meet in the early 1960s. Nowak was a longtime promoter of the area, conducting the national contests in 1938–1939 at Frankfort. Behind Nowak to the left is Fred Herman, who was actively involved with the Adrian (Michigan) Soaring Club before he moved permanently to Frankfort in the early 1960s.

Winch operations from an old automobile launched many a sailplane into the air a few miles south of the Elberta pier during the late 1950s and early 1960s

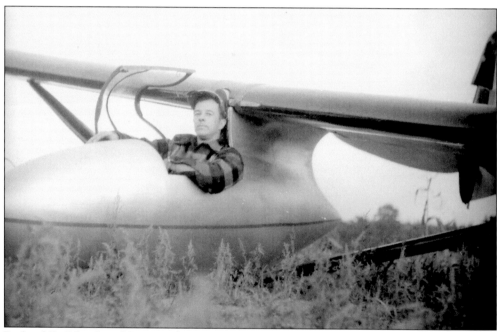

Richard E. Schreder of Bryan, Ohio, was the U.S. National Soaring champion in 1958, 1960, and 1966. He was a regular participant at the Midwest Soaring Meets held in Frankfort during the 1950s and was among the initial class of inductees in the Frankfort-Elberta National Soaring Hall of Fame in 1973.

Pilots, their spouses, and their children pose at the awards ceremony at the end of a three-day Midwest Soaring Meet at the Frankfort airport in September 1953. Robert Bauer of the Toledo Glider Club recorded the best altitude gained (1,700 feet), and Ray Jackson of the Detroit-based Vultures Club won the spot landing event bringing his tan and red Schweizer 2-22 to a dead stop eight inches from the marker flag.

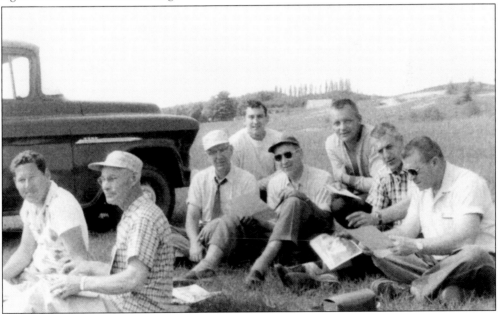

Two years prior to Zada Price's untimely death in 1960, the Northwest Soaring Club began to expand its membership. During this informal meeting, from left to right, Jim Holtrey, Zada Price, Howard Gladman, Roy Price, Tom Barrett, Stollie Larson, Don Zimmer, and Bob Weigand discuss soaring issues. New members Roy Price, Zimmer, and Weigand were from the Muskegon area, while Gladman and Barrett were from Leelanau County.

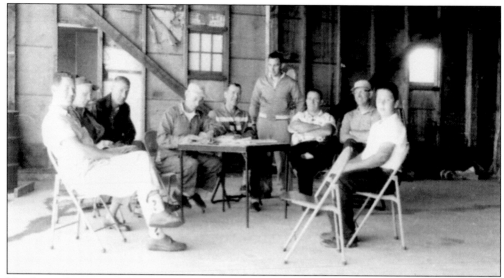

Northwest Soaring Club meetings in the 1950s were pretty informal as secretary/treasurer Zada Price (fourth from the left) conducts this meeting in the Frankfort airport hangar. A financial report of a Glider Fly-In weekend at the end of August 1958 shows that disbursements included $32.76 for 26 pizzas and $3.79 for Kool-Aid, ice, and decorations. The Frankfort Chamber of Commerce donated $100 and the Village of Elberta $50. During that weekend, glider rides netted $44 while expenses included six quarts of oil ($2.40) and 30 gallons of gas ($12) for the tow plane.

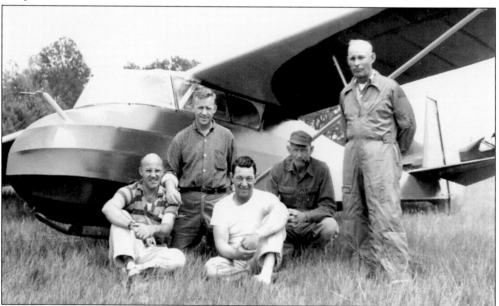

Elberta's Zada Price (far right) poses with Northwest Soaring Club members, from left to right, Eugene "Hunchy" Hansknecht, Dale Houghton, Elton Dinger, and Jim Tanner. Every Labor Day weekend, the club would put on a major Midwest Soaring Meet. Price's daughter, Elaine Larson, once characterized her father saying he was "very dedicated no matter what he set out to do. He was a community-minded man who sank himself completely into whatever worthwhile local project was in progress at the time."

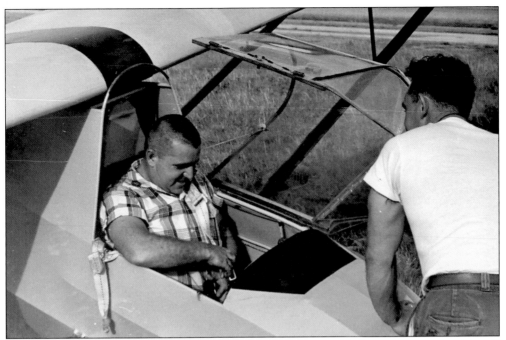

Northwest Soaring Club member Bob Weigand of Muskegon, Michigan, is strapping himself into a Schweizer 1-19 single-place sailplane during a meet in 1959. Roy Price of Rothbury (near Muskegon) is holding the ship steady.

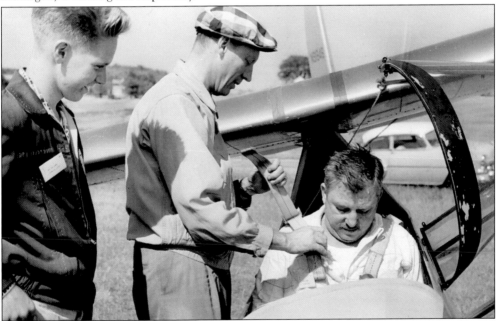

Toledo's John Nowak is strapped into his sailplane by Harold "Slim" Jones during a meet at the Frankfort airport in the 1950s. To the left is Detroit's Bobby Kellner, who soloed at Frankfort at the age of 16. Robert D. Kellner went on to get his Gold Badge (440) and was 223rd to obtain the Robert F. Symons Wave Memorial One-Lennie Pin, symbolic of a flight between 25,000 and 35,000 feet, altitude-wise..

Chuck Kohls receives the "winner's rewards" from the co-queens of the 1953 Wright Memorial Contest in Dayton, Ohio. Meets in Dayton, Toledo, and Bowling Green, Ohio, and Frankfort and Adrian, Michigan, were part of an annual program of Midwest Soaring Meets during the 1950s. Kohls was an early promoter of gliding, participating in the exploration and use of the Lake Michigan sand dunes for the sport. Kohls, at one time a member of the Adrian Soaring Club, was holder of Diamond Soaring Badge 65 and Gold Soaring Badge 58. The Silver Badge, Gold Badge, and Gold Badge with Diamonds are soaring awards granted to pilots for flights that satisfy the qualifications of each badge as set forth in the sporting code of the Federation Aeronautique Internationale (FAI). In the case of the Gold Badge, one must attain a flight of at least 300 kilometers (186.4 statute miles), a flight of at least five hours, and a gain of at least 3,000 meters (9,842 feet). Every flight must be supervised by an official observer.

Six

THE GLORY YEARS REVISITED
1961–2006

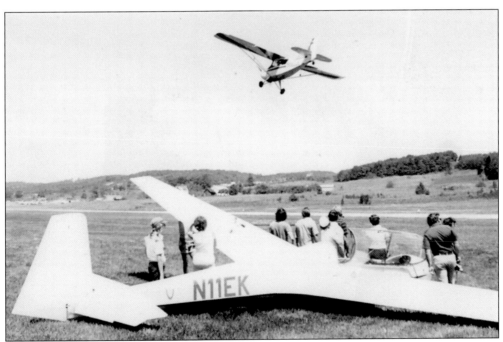

A towplane gets ready for a landing at the Frankfort airport at the 1974 Fly-In Breakfast during the Second Annual National Soaring and Hang Gliding Festival. The towplane would take the glider up to either 2,000 or 3,000 feet before release.

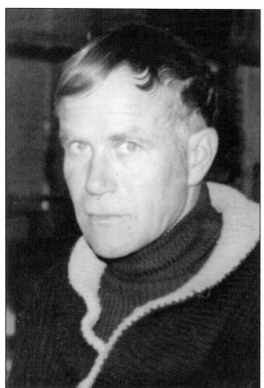

One of the longtime promoters of soaring in Michigan (with the Sandhill Soaring Club, the Vultures Soaring Club, and the Northwest Soaring Club of Frankfort) has been Eberhard F. Geyer. A German native, he learned his soaring from legendary great Wolf Hirth, and Geyer worked in the Schempp-Hirth glider factory. Geyer began teaching Allied soldiers stationed in post-war Germany the art of soaring. He once recalled what Hirth had told him that it was "his responsibility to soaring and flight to share his experience with others and to others as he had been taught." Geyer received his Gold Badge in 1967 and his Diamond Badge the following year. He has given over 2,000 hours of instruction.

At the first National Soaring and Hang Gliding Festival in 1973, four legendary glider pilots along with longtime promoter Elaine Larson look to the sky to see the many sailplanes in the air that afternoon. Pictured are, from left to right, Eberhard Geyer, Larson, John Nowak, R. E. Franklin, and Ted Bellak.

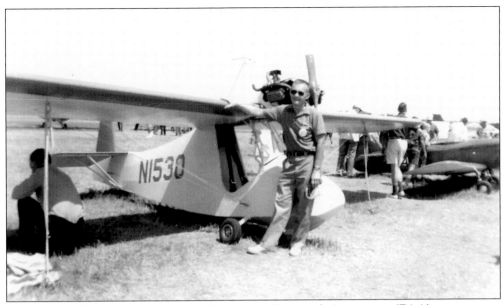

Ken Flaglor, a longtime regular at the Experimental Aircraft Association (EAA) conventions, is shown with his Volks-powered ultralight at Rockford, Illinois, in August 1967. The annual Experimental Aircraft Association convention is the largest and most significant aviation event in the United States. Flaglor's first experience with aviation was flying gliders in the late 1940s.

Nearly 40 years after his first glider flight in northern Michigan, R. E. Franklin (foreground) takes a ride in the *City of Frankfort II* sailplane with his son Charles at the controls during the first national soaring festival in Frankfort in July 1973. John Nowak, who was with Franklin on those Sleeping Bear Dunes expeditions in 1935, gets ready to attach the tow rope to the glider. R. E. Franklin passed away in Arizona that fall.

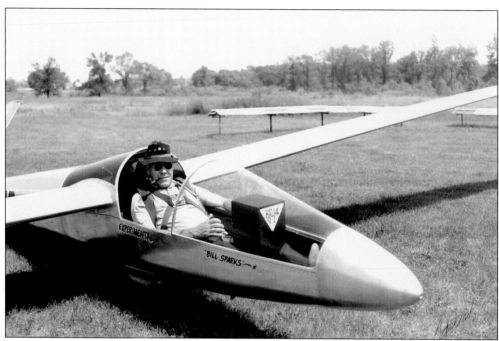

Bill Sparks of Grayling, Michigan, shows off his Experimental HP-14 sailplane that was designed by Frankfort soaring meet regular Richard Schreder. In the HP-14, Schreder used lower wing loading and reduced aspect ratio aiming to create a potent Open Class sailplane that would do well in weak conditions. HP-14s are famous for the effectiveness of their flaps for landing.

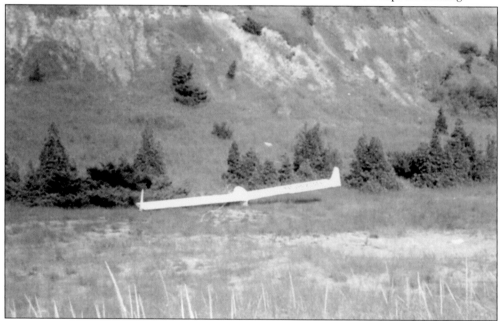

One of sailplane designer Jim Marske's first projects was the XM-1, a tailless glider. It was designed and constructed as a research and development sailplane in the late 1950s. He began flight tests in 1957, modified them between college studies in 1958 and 1959, and then was flying the sailplane at the Elberta beach area (above) in 1960.

In January 1972, from left to right, Jack Laister, John Aronson, Vic Saudek, and Peter Riedel reunited at Rosamond, California. Laister, whose interest in gliders and sailplanes produced not only the sporting sailplanes for which he is famous, but also the CG-10A, a war glider that could carry up to 52 troops. This glider, at 17,600 pounds, is the heaviest glider ever "snatched" from the ground by an aircraft in flight, a B-17F that had the pick-up unit installed at All American Aviation, where Saudek was employed before his work with NASA.

Robert Sparling (left), who won a Zenith radio for "most interesting new sailplane design" at the 1940 American Open Soaring Meet, goes through soaring memorabilia with historian Pete Sandman in Frankfort, Michigan, in the fall of 2002. Visiting relatives in the area, Sparling had come from Prescott, Arizona, where he was still actively involved in the sport. At the 1940 meet, he also won $20 in a spot landing contest.

Frankfort-Elberta National Soaring and Hang Gliding Festival executive director Pete Sandman (left) poses with Pauline Price Warner (center) and Elaine Larson, the wife and daughter of 1973 Hall of Fame inductee Zada Price. Zada Price was killed in a glider crash in 1960 in Midland, Michigan. Since his death, Elaine Larson and her husband, Stollie, have carried on the promotion of soaring in the area.

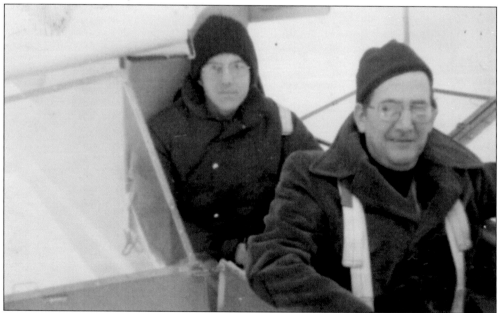

Fred Herman (foreground) and Bruce McClymond, both members of the Northwest Soaring Club that was reactivated March 1, 1973, have just landed the club's Schweizer 2-33 on the ice of Crystal Lake at the 1975 Beulah-Benzonia Businessmen's Winter Carnival. The club's participation turned out to be one of the most successful ventures of the winter event.

A perfect landing on the frozen runway of Crystal Lake, north of Frankfort, is seen here during a winter carnival in 1975 when members of the Northwest Soaring Club gave glider rides. The Schweizer 2-33 returns from taking a passenger up to experience the thrill of silent motion on a beautiful February day in northern Michigan.

For 12 years until 1984, Frankfort put on a National Soaring and Hang Gliding Festival and attracted upwards of 60,000 persons each year. In fact, during the 1976 bicentennial year, Coca-Cola, which featured a national event from each state and depicted that event on the inside of their twist-off bottle caps, chose the Soaring Festival to represent Michigan. The first five years of the festival, the town recognized the legends of soaring and hang gliding and held a banquet each year with elaborate induction ceremonies.

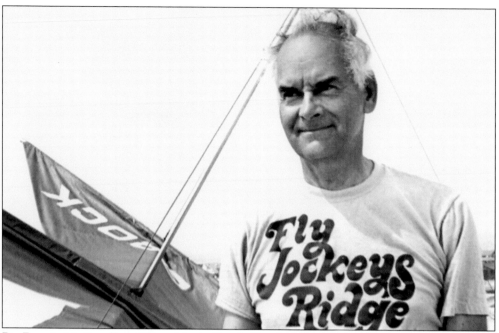

Dr. Francis M. Rogallo, of Kitty Hawk, North Carolina, attended the 1974 hang glider meet on the Elberta beach that attracted nearly 200 kite pilots. Rogallo, the father of hang gliding, along with his co-inventor, Gertrude (his wife), filed for a patent on the Rogallo Kite Concept in the late 1940s, which was granted in 1951 and reissued in 1965. While with the National Aeronautics and Space Administration as an engineer, he planned and supervised the theoretical and experimental aerodynamic research and airplane development investigations conducted by Langley's Full-Scale Research Division.

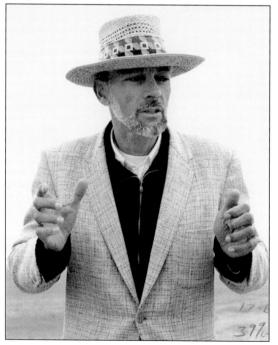

One of hang gliding's earliest promoters, Richard Miller wrote two the first books on ultralight flight, *Without Visible Means of Support* and *Soaring Yearbook*. He was the first editor of *Low and Slow and Out of Control* magazine. Miller, who was inducted into the hang gliding division of the Frankfort-Elberta National Soaring Hall of Fame in 1977, designed the Bamboo Butterfly kite in 1965 and the Conduit Condor a few years later.

Bill Bennett and his Delta Wing hang gliders played a significant role in promoting hang gliding into a popular sport enjoyed by thousands of people worldwide since the late 1960s and early 1970s. Nicknamed "The Birdman," Bennett was the first hang glider pilot to fly higher than a mile, the first to travel 200 miles under tow, the first to pilot a motorized hang glider, and the first to build and fly a hang glider tricycle. In 1969 he circumnavigated the Statue of Liberty, landing at its base, and that same year, he set a world record when he launched a glider at 10,000 feet from a hot air balloon. Bennett died on October 7, 2004, in an accident in Lake Havasu City, Arizona, when the motorized hang glider he was piloting lost power and crashed. He was 73.

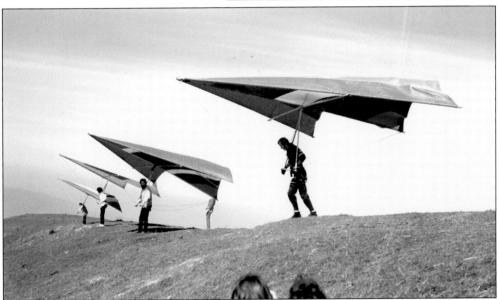

David Kilbourne was presented his hang gliding division hall of fame plaque in Frankfort at a banquet on July 5, 1975, by LeRoy Grannis of *Hang Gliding* magazine. Kilbourne had been voted into the hall of fame as he was the first person to foot launch a Rogallo-type hang glider. Kilbourne was also instrumental in safe, but free development of foot-launched hang gliding in the early 1970s.

Hang glider pilot Rick Vandersloot of Grand Rapids was the president of the Frankfort-based Betsie Bay Bluff Buzzards, one of the first hang gliding clubs in the Midwest. Cindy Plumstead was the secretary-treasurer of the club that was based in the Michigan Manta kit shop owned by Dave Nelson. In October 1974, during a Fall Fly-In weekend, Vandersloot won the hang gliding competition against 28 kite pilots.

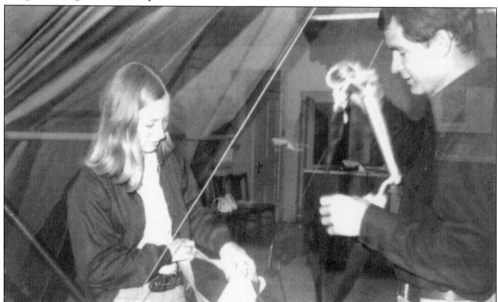

California hang glider pilot Dave Nelson (right) ventured into Frankfort with Barry Hawthorne in the fall of 1973. A few months later, businessmen had arranged for a place to set up a hang glider shop (Michigan Manta) and for him, his wife Judy, and son Sid to live in the back portion of the building. For a half dozen years, Nelson (shown teaching the basics of the kite equipment to Frankfort's Cathy Norton) ran his shop and conducted the Midwest Invitationals.

Early Frankfort-Elberta soaring pilots Robert Denton (left) and Ted Bellak reminisce during the National Soaring Landmark ceremonies in Frankfort May 6, 1992. Bellak flew in from Hawaii for the occasion. Frankfort became the fourth site to be designated national status and the event seemed the spur on the soaring landmark program. There had not been a landmark ceremony in nearly seven years, and now there are 14 sites with national soaring status.

At the dedication weekend of the National Soaring Landmark in Frankfort in May 1992, Ted Bellak (left) talks sailplane design with Mike Ziomko (seated at right), the director of Institutional Advancement at the National Soaring Museum in Elmira, New York. Also pictured, from left to right, is Joan Johnson, wife of longtime soaring promoter Stanley Johnson; former National Soaring Hall of Fame executive secretary Elaine Larson; and Charles Franklin, son of Roswell E. Franklin.

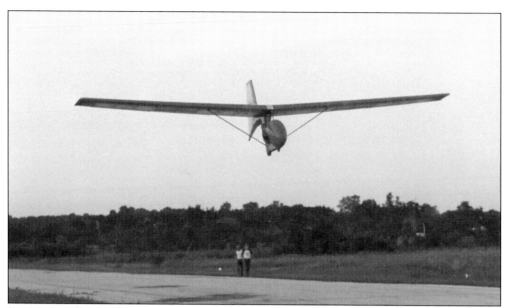

Jim Markse flies his Monarch, an ultralight sailplane, at the Frankfort airport in 1974. The Monarch is a kit sailplane constructed by the home builder from pre-molded fiberglass parts bonded together with epoxy glue. Fin and wing ribs are cut from foam plastic and capped with wood strips. The structure is fabric covered and doped. Construction time is less than 200 man hours. The cost of the kit in the mid-1970s was just over $1,000.

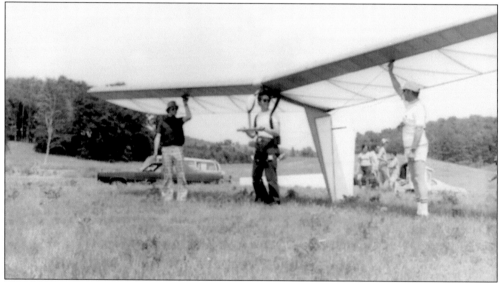

One of the more innovative sailplane designers is Jim Marske, who developed the XM-1 when he was in college and tested it at the Elberta beach in 1960. He has designed an entire series of Pioneer sailplanes and now the Genesis series. After he designed the Monarch, which he brought to Frankfort a number of times, he shifted his focus to designing high-performance, low-drag airfoils to achieve lower sink ratio and increase the speed range of the aircraft. In July 1974, as the guest speaker, he told attendees of the Frankfort-Elberta National Soaring and Hang Gliding Hall of Fame banquet—including hang gliding legends Bill Bennett and Dr. Francis Rogallo—of his years of work to design the Monarch ultralight sailplane.

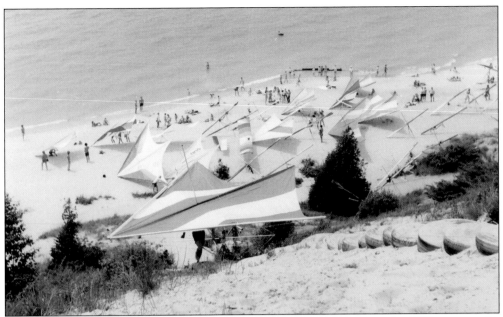

Nearly 200 hang glider pilots from 13 states and Canada participated in the 1974 meet on the Elberta bluffs overlooking Lake Michigan. Tom Peghiny, a 19 year old from Massachusetts, won the meet with three straight bulls-eyes in the spot landing contest and three flights of 50 seconds or more to score 71 points. The weekend before, Peghiny had won the Tactile Meet at Kitty Hawk, North Carolina. Among the 198 pilots registered were 11-year-old Hall Brock of El Sequndo, California, who made it to the finals, and Sue Hosta, the only female in the competition.

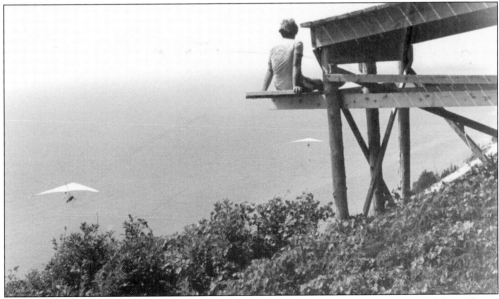

When Detroit's Grant Smith and Dean Luedders brought a hang gliding group to Frankfort-Elberta in July 1973, the sport was the highlight of the town's first National Glider Festival. That summer, even Green Bay Packer Hall of Famer Ray Nitschke could be seen helping hang glider pilots get their kites up the steep terrain to the top of the bluffs. By the next year, steps made of used tires and a launch platform were built for the 1974 meet that attracted nearly 200 kite pilots.

Longtime Frankfort area airplane and glider pilot Stollie Larson gets ready to pilot the Northwest Soaring Club's new Schweizer 2-33 in 1973. Club member Mike Jones gets ready to steady a wing prior to takeoff.

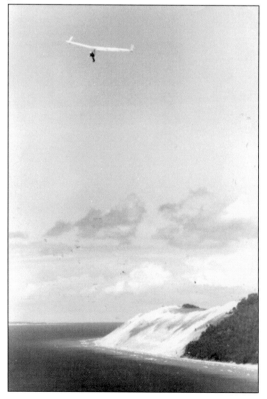

On October 12, 1978, the 25-year-old hang glider pilot Larry Damic flew his Manta Fledge II rigid wing kit from the Elberta Bluffs, south past the Watervale gap, down to Arcadia and back; a trip of nearly 17 miles. It was the first time any hang glider pilot had flown past the gap and prompted Frankfort hang glider dealer Dave Nelson to say "it is the biggest thing in hang gliding that has happened here." Damic said "When I got to the gap, I was below the trees . . . but I just kept following the contour breaker of the bluffs. The funneling through the gap was just right," also noting that the winds were 25 miles per hour due west. Damic was from Chesaning, Michigan, and had been flying three years prior at Point Betsie.

Traverse City's Craig Carlson, a member of the Green Point Flyers Association, is ready to be catapulted into a launch at Thompsonville in the early 1980s. Green Point is a piece of property owned by the association just south of the Elberta bluffs that was the site of the hang gliding meets of the 1970s.

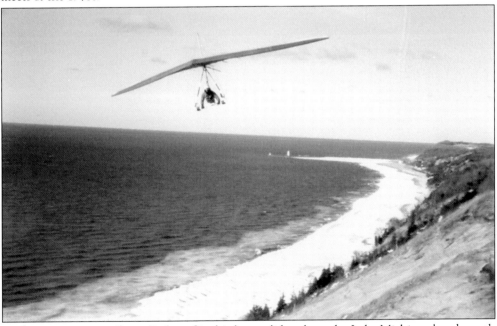

Real estate appraiser Craig Carlson flies his hang glider along the Lake Michigan beach south of Elberta. Hang gliding and paragliding enthusiasts still use the Elberta bluffs and areas in the Sleeping Bear Dunes National Lakeshore to soar, although permission and a satisfactory hang gliding rating is needed at the dunes.

Longtime glider pilot Dick Ide navigates an ASK 13 glider over Crystal Lake as he heads toward Lake Michigan under the tow of a Bellanca Scourt aircraft, during a demonstration flight in July 2005. There are about 30 active glider pilots in the Northwest Soaring Club headed by president Pete Brancheau. (Courtesy of Doug Tesner/Traverse City Record-Eagle.)

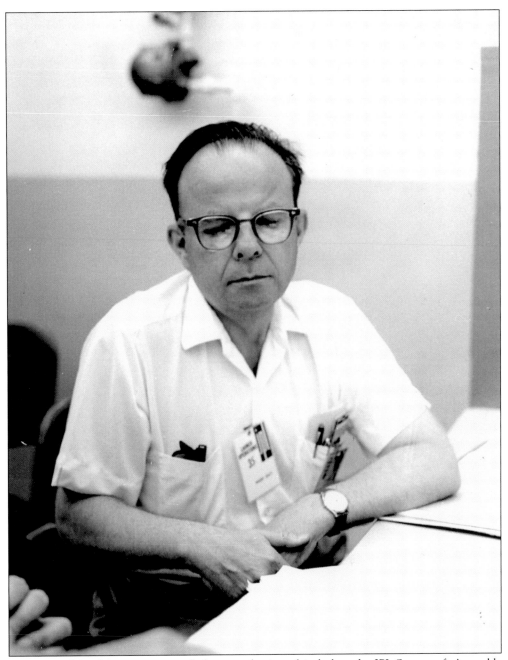

Victor Mead Saudek, in an unposed photograph, sits at his desk at the JPL Spacecraft Assembly Building at Cape Kennedy Space Center, Florida, on November 7, 1967, setting up to launch Surveyor VI on an Atlas-Centaur booster for a successful moon landing. "I looked around that day and saw 14 persons including myself who were involved with flight in the Frankfort, Michigan, area in the 1930s," Saudek later said.

DISCOVER THOUSANDS OF LOCAL HISTORY BOOKS
FEATURING MILLIONS OF VINTAGE IMAGES

Arcadia Publishing, the leading local history publisher in the United States, is committed to making history accessible and meaningful through publishing books that celebrate and preserve the heritage of America's people and places.

Find more books like this at
www.arcadiapublishing.com

Search for your hometown history, your old stomping grounds, and even your favorite sports team.

Consistent with our mission to preserve history on a local level, this book was printed in South Carolina on American-made paper and manufactured entirely in the United States. Products carrying the accredited Forest Stewardship Council (FSC) label are printed on 100 percent FSC-certified paper.

MADE IN THE USA